CN00843109

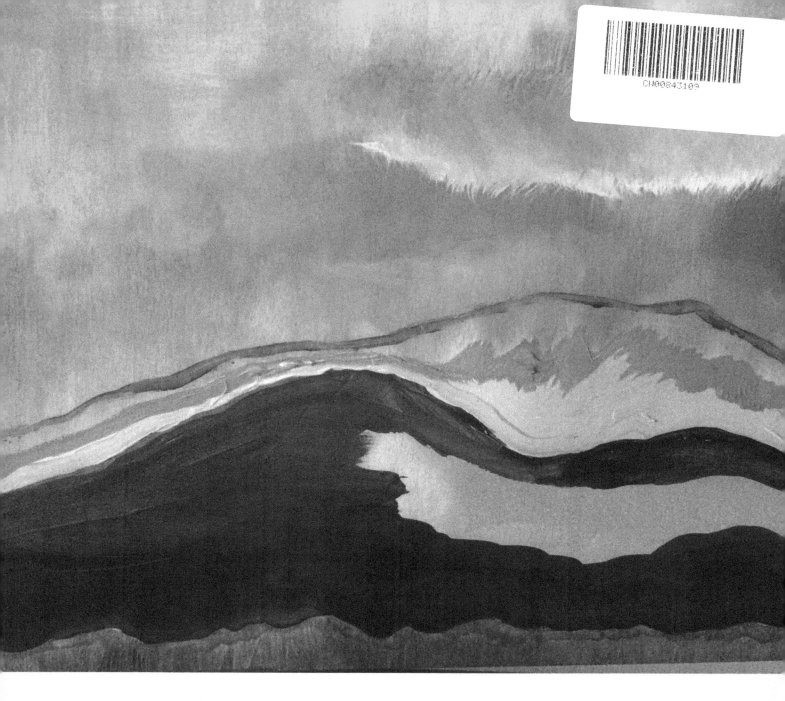

Manifestation of Self
Within Place

A love story in pictures

Kumari Patricia Soellner

AuthorHouse™
1663 Liberty Drive
Bloomington, IN 47403
www.authorhouse.com
Phone: 1 (800) 839-8640

© 2018 Kumari Patricia Soellner. All rights reserved.

No part of this book may be reproduced, stored in a retrieval system, or transmitted
by any means without the written permission of the author.

Published by AuthorHouse 07/10/2018

ISBN: 978-1-5462-4794-4 (sc)
ISBN: 978-1-5462-4793-7 (e)

Library of Congress Control Number: 2018907253

Print information available on the last page.

Any people depicted in stock imagery provided by Getty Images are models,
and such images are being used for illustrative purposes only.
Certain stock imagery © Getty Images.

This book is printed on acid-free paper.

Because of the dynamic nature of the Internet, any web addresses or links contained in this book may have changed
since publication and may no longer be valid. The views expressed in this work are solely those of the author and do not
necessarily reflect the views of the publisher, and the publisher hereby disclaims any responsibility for them.

authorHOUSE®

ABSTRACT

This auto-ethnographic work examines interdisciplinarity in the written and visual sense. It is a story of migration into a new Place and the acceptance of Self in that Place. It is about the essence of Self manifested in the Visual Landscape and taking pride in the authentic voice that emerges through paintings, photography and the written story. This work has been about acceptance of Self and the celebration of a Place-Based Artistic Practice that reflects an understanding of community, individuality, ownership and pride.

<u>KEY WORDS</u>

Authentic Self

Visual Landscape

Place-Based Artistic Practice

Migration

Dedication

My artistic practice embodies my voice as well as my choices. This work is

dedicated to the five important choices I made in my lifetime:

Christopher, Benjamin, Mary Katherine, Rachel Nakia and Erik. Without them my work

would lack the commitment, compassion and courage visible in my creative life.

In Recognition

This work was completed over the course of my three years of study in the MFA Interdisciplinary Arts Program at Goddard College in Vermont. The brilliant faculty who worked alongside me included: Gale Jackson, Judy Hiramoto, Pam Hall, Cynthia Ross and Danielle Boutet, the Program Director. Students who find their way to this magical place called Goddard College, all leave with greater commitment to their art, their intellectual selves and to their home communities.

Foreword

I wrote this manuscript during my three years in the MFA program at Goddard College from 2007-2010. It is an Interdisciplinary MFA and one of the few in the country. It allowed me to write, to process my artist life and to paint and paint and paint more.

This manuscript is designed to encourage everyone to look closely, be aware and fall in love with Place. Love where you live. Embrace subtle changes in light and texture of the clouds and huge transformations that weather and seasons can bring. This book is about waking up to our lives within Place and feeling pain, sorrow and enormous joy and living fully in every moment.

I fell in love in Cabot, Vermont both with the place and a man named John Young. He walked into my world at a time when I needed him and my children did, too. While my marriage had ended, I held no bad feelings towards my former husband and in fact, the way I see it, people like places come into our lives for a reason. My ex-husband blessed me with five wonderful children who are my world and beyond. He has moved on to a better marriage than we had and I am happy for that because we all deserve unconditional love.

Life can make us unsettled and uneasy and stress can make us come undone. The key to surviving stress is to surrender to it with an open heart and smile. I learned that and much more from John. He was a man who suffered endlessly his whole life yet never regretted a moment that he had experienced. In particular, he never regretted meeting me.

Sometimes we try to explain why things happen or justify life's events or even deliberately try change events, but, in the end, we often must live with what happens. Sometimes we embrace changes or we constantly fight them and become bitter and resentful. While we may not control how others react to us, **we can control how we react to them.**

I believe that Vermont defines my work as an artist. Vermont has changed me as a person, no longer a consumer but now a producer and fully engaged actor in my life. Places like Cabot exist all over Vermont. There are communities that hold no pretense, no ego, and no pre-determined outcome. Mollie Butler Plowden, a woman from New York and from Putney, Vermont, musician and outspoken liberal who lived to be 99, said it the best, "Vermonters are the salt of the earth."

Vermont boasts of Bernie Sanders and Howard Dean but what we really hold dear is the way a wry sense of humor, independent thinking, outspoken radical flair, and community building defines this Place we call Home. I appreciate everyday waking up to the long range view of the Green Mountains and I await my years ahead with the spectacular wisdom, human compassion and colors that my paintings depict.

I am grateful to be able to paint in Vermont.

Kumari Patricia

2018

Weaving My Identity Into Place

Throughout my work at Goddard in the MFA Program, I have inquired, examined and reflected on the importance of place in my life. I moved to Vermont because this place attracted me for two decades. I met significant people here and through those connections as well as through the image of the mountains as I traveled in and out of Vermont, I knew this place was special.

There was a beckoning. The call brought me here to stay with my children, my cats, and my dog and with a willingness to uncover my true self. The essence of self has been revealed to me through my artistic practice, which weaves a unification of Self to Place.

I hope my writing and my art make that clear.

ARTIST STATEMENT

My artistic practice consists of layers of untold stories both within myself and within the landscape. I am a painter, a story maker with collages, and an interdisciplinary artist who makes meaning in the context of place and community. I am a writer who creates poetry that reflects images from place and travels. I find myself within the boundaries of a life that is full, interpretive, and ever-changing. My yoga practice strengthens my vision and adds clarity to the expression I seek. I have emerged into my current practice from a disciplined life in the study of drawing and anatomy and I take that rich gestural line with me as I interpret Place within my practice now.

Contents

The Beginnings of Finding Place

Once upon a time there was a woman with a smile.

This woman lived a long life in a place she did not like. She grew her hair long and white.

She wore colorful clothes and taught many children how to draw and paint.

This woman hid her unhappiness behind her smile and her white hair and her colorful clothes.

This woman grew strong.

This woman understood that she had lost the love of the man she married. He was rude. He was disrespectful.

He was controlling and anxious and angry and irritable. This woman with the smile tried to be pleasant, but her pleasantries needed to stop.

She needed to find her voice.

She needed to find peace.

The woman with the smile and the long white hair began a journey. She packed up her many children and her cat and her dog and her colorful clothes, and she began the journey that brought her to the tall mountains.

And on her mountaintop she found no disrespectful man, no rudeness, no anger, no irritability, no control.

There was quiet.

There was uncontrollable weather and moving winds that spoke to her soul.

There were people who had lived on this mountain forever. Some spoke to her tenderness.

One spoke to her with love in his heart and with pain in his body.

He touched her soul.

He moved past her in the night.

Morning brought new journeys and new sunrises and more mountains to explore.

The woman with the smile and the long white hair was filled with peace.

She had found her home.

This work is dedicated to the importance of finding love within any landscape.

Chapter One – Journey into Vermont

Land Speaks

I often wonder when I look up to these mountains in Vermont where the sky actually begins. I think it surrounds me, but then I see its passionate breath touching the mountaintops each morning, and I wonder how the sky can remain at such a distance from me. I am sure that in the foggy mornings the mountains whisper stories to the fog. Those mountains do have stories. They hold stories and secrets from the many, many generations that have passed through their creases. There were births. There were deaths. And there were and still are families, created by blood and survived by friendships.

The height of the mountains moves slowly with a delicate flow to the valleys. Farms sit in pride throughout the valleys. Some old buildings have been carefully restored to their former years, while others sit in disrepair with sadness and age and tears running forth. Ghosts and misery hide in the corners of the restored and disheveled buildings alike. Joy needs more coaxing to come out. She has been locked away in the mortar that builds memories not believing that life can hold crimes and ugliness. Joy hidess in the shadows of life.

Wherever I have traveled in the world I've believed that the landscape could tell me more stories than I would want ever to hear. In 1987 I traveled alone in Jerusalem, the Old City, and then farther into the border city of Bethlehem. By the time I got to Bethlehem, I met a young man, a fast romance, who traveled with me. He said he was a Druid but left his family, never able to return again.

He took me to small towns where I might never have traveled, but because he seemed accepted in both Palestinian and Jewish territories, it seemed safe. I could hear bombings in the distance as we traveled. I remembered thinking how precious a place I was entering, yet one with such conflict and continual torment over its land.

When I left Israel, I was stopped for the usual questioning at the Tel Aviv airport. I was naïve and I answered all their questions about where I had traveled, times I was alone or not alone. The questioning became more intense and pretty soon my bags were being torn open and everything pulled out. The inner lining was ripped open. I was tagged with florescent orange stickers and escorted onto an upstairs station.

Although I remained calm, I was suspicious about why I was the focus of their attention. In a separate room, a respectable female Israeli officer strip-searched me. She seemed to think I was okay and sent me on. Although I was able to board my flight (very late), I had to keep the stickers all over my backpack and body and to be seated in First Class. Not bad, I thought, and yet I still wondered why?

Later in the flight, after chatting with others nearby, I discovered that Israeli officials take the initial questioning very seriously. They were alerted to a problem as soon as I told them I was a non-Jewish female and I traveled in border towns. I could have been handed something or worse, I could have had something planted in my bags by this stranger I traveled with briefly.

Israelis take their land and honor and safety very seriously. Israeli and Palistinian land has been in dispute, in war, for so long, and people die nearly every day over that war. Lives of individuals, thus families, and religious, historical identities are lost over that land. I doubt if any land on our planet holds any richer, deeper, more historical secrets than the Middle East.

Landing in Vermont

Vermont was declared a state in 1791. However, there were Native Americans and settlers here long before that time, and the moose, wild cats, deer and other creatures all survived much longer than that. Vermont has been home to many.

I discovered in *Hands on The Land: A History of the Vermont Landscape* by Jan Albers (2000) that the native people in Vermont were doing a lot more than just passing through. In three early periods: 9000-7000 BC, the Paleoindian, 7000-900 BC the Archaic and 900 BC –1600 AD the Woodland, they made their homes here.

There is some current thinking that the Abenaki, the well known Vermont indigenous people, descended from the development of these other earlier tribes in the area. The Abenaki had an interesting philosophy of adjusting and adapting to the Vermont landscape. They were settling into this region in the 1600s, and they adapted to nature rather than adapting nature to themselves.

The Abernakis' attitude towards the land was an extension of their spiritual beliefs. They attributed personal qualities to many objects within nature and thus treated nature with honesty and respect, as they would a person.

That's not to say that the Abemakis did not alter the landscape in order to survive the harsh winters. They knew how to travel from lowland in the coldest months to the higher elevations for food as February and longer days approached. While they did clear paths and create homes to stay warm, their spiritual connection to the land gave them a reputation for a devotion to a creator bigger than they were who was responsible for creating the natural beauty surrounding them.

How A Landscape is Created

The Abernakis had the right idea about nature. It is good to let nature drive the human and not the other way around. Because we have allowed men and women to exercise some control, we are now in an environmental disaster.

The natural landscape has suffered from human attempts at controlling the environment, change the face of the city, create urban sprawl, and take over farms for the sake of suburban networks. The beauty of our landscape no longer looks anything like it did fifty years ago.

For example, when I returned to my hometown area of Cincinnati in 1997 to care for my father, I was shocked at how ugly the outgrowth looked. I could not find my way around the outskirts of the city because the roads were totally developed from graveled, dirt backroads into highly developed subdivisions.

Cincinnati had exploded. Its population was large and out of control and, consequently, the growth of industry and environmental hazards was out of control, too. Today Cincinnati is one of the top polluted cities in America.

Jan Albers explains that landscapes do not just spring fully formed from the earth. The landscape is the accumulation of many decisions by humans about how things should look and function. We are responsible for what we are living with today.

Landscapes have everything to do with people. The land shows our values, our care, our compassion and definitely, most definitely, our priorities. If we care about our ground water, then we protect it. If we care about old buildings, then we try to maintain them. If we care about raising our children in a pollution free place, then we find a way to make it happen.

Artwork 1: *Camel's Hump***, Oils and Acrylics, 2009**

Chapter Two – Why Place Matters

Images live on in my memory.

I was born in Cincinnati, Ohio, a town known for baseball, its brewery and its race riots in the sixties.

I grew up in a rural area outside of the city. We lived on a dirt road surrounded by woods until pavement came and a subdivision developer bought the land. Then people, cars, and pollution moved in. Our plot of land seemed to shrink.

My father was a teacher at the local parochial school, an early morning newspaper carrier and a butcher at the local deli. He never finished college, but was still their best teacher. My dad's life was about connections with people at his school, in the town and its outskirts. His happiness came from understanding that he made a difference wherever he went.

My mother suffered enormous anxiety throughout her life. She held onto regrets, obsessed over her daily pains, and eventually became completely agoraphobic, choosing never to leave her house during her last decade (60-70 years old). No two people in my life could demonstrate the yin/yang of a relationship better than my parents. They held onto each other for 42 years of a marriage because they believed that was the right thing to do. My mother's family hailed from Alabama and was Southern Baptist, while my father's family was a very large strict Catholic clan in Cincinnati. My parents met on a blind date after my mother's former fiancé was killed in the war. My parents' relationship resembled their parents' relationships. My paternal grandfather was open, kind-hearted, and nurturing, while his wife was firm, dictatorial, and depressed. My maternal grandfather was stubborn, intelligent yet arrogant, and strict both in his business practices and with his wife and child. My maternal grandmother was meek, hard-working, and always anxious and worried. I find I sit somewhere in the murky mess of all of these ancestors, hoping I carry on the best traits but knowing I could struggle with the worst.

As a young child and young adult, I grew up parenting my mom but being nurtured by my dad. He knew I would be an artist and teacher and he never understood why I had to travel, explore and try new things only to select what he knew all along was best for me. My dad longed to have his morning coffee at the bakery with friends and linger over the baseball results from the day before. I could not wait to leave Ohio and discover my next journey.

Traveling has always allowed me to look beyond who I am. My travels allow me to pretend, to meet people and let them see whoever they see and to know I may not stay in that world for long. Our time here is all about our manifestation of intent.

In *The Invisible Landscape* Kent C. Ryden calls the many places that affect us as "invisible landscapes." Ryden suggests that the places are significant to us not just because of the way they look, but because the impression they make upon us. The beauty that each of us experiences in these places has nothing to do with objectified aesthetics.

My childhood impression of Ohio was affected by the race riots of the 60s. As my father looked at the neighborhood where he grew up, he saw destruction. Never one to become angry, he simply said, "This was going to happen at some point because whites do not know how to listen."

The longer my dad lived in Cincinnati, the more he saw the landscape within his community change. He saw anger and frustration in both whites and blacks. He saw his city fall apart and try to re-build, only to find the task impossible. The dialogue had been compromised since days of slavery when black slaves crossed the Ohio River hoping for their freedom. The sad reality was that Cincinnatians often housed those slaves on false premises of freedom while turning them over to their white slave masters the next morning. Suddenly the race riots of the 60s were proof to me that the landscape of that city would never change. All I felt was a need to get out.

These stories of slavery and deception affected my sense of self and my torment, embarrassment and lack of pride in being a "Cincinnatian." By 18, I was ready to leave.

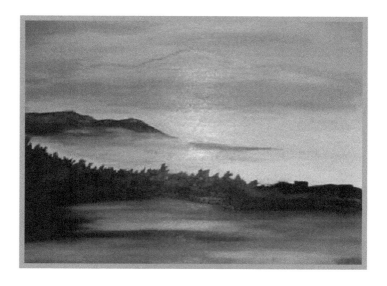

Artwork 2: *An Early Morning*, Oils on canvas, 2007

Place inside Me

Wondering place

establishing my sense

of permanence

impermanence

Feeling the tides

roll over me

and mountains smother me

Time gives me strength

waiting

inhaling

and holding on

—Kumari Patricia

Chapter Three – The Breadth of Place

After 18 my travels included college at Edgecliff, Mount St. Joseph in Ohio; a teaching experience at Alpha Primary in Kingston, Jamaica; studies in figure drawing from two masters at The Art Students League in New York City; and then my first teaching experience out of college at my former elementary school in Cincinnati. I became their first art teacher. Two years after that teaching position, I pursued my Masters in Art Education from the Rhode Island School of Design. I studied for a summer semester in Holland, living in a small village called Amersfoort and working out of a Dutch artist's studio. At RISD I met a diversity of artists and there in the rises of the hills of Providence I learned the meaning of experience and commitment to my life as an artist. I was taught that before I could teach art, I must first be a dedicated artist.

My artistic engagement is with me every day. I hold onto images that surround me whether in Ohio or Michigan or Rhode Island or Vermont. I find that traveling enriches my sense of self and allows me to develop a rare and magical impression of a place. In Jamaica I saw poverty, discrimination, and class differences. I also saw the festivals, heard the reggae music, tasted the food and climbed the mountains. I was able to live on the grounds of the complex of schools where I taught. I taught at Alpha Primary but I also observed at the private school, the equivalent of the high school where students move through "forms," and the Boys' Reformatory. I lived in a house with a Jamaican high school girl. (I admit to having enjoyed some Jamaican rum with her and another US volunteer on a weekend or two!) We all had limited resources so would hitchhike into New Kingston, the resort area, and sneak into an elegant hotel where we would change into bathing suits in the bathroom and go poolside for a dip. That was our Saturday escape from the true hot inner city poverty we experienced during the rest of the week.

My travels nurture my creativity. I remember these places and the cultural interactions that form their context for my learning. It is not about finding elegance; it is about finding essence and truth wherever I go. In Israel, before I traveled on my own, I lived with my friend on a kibbutz near Elot. There I participated in the same lifestyle, chores and common occurrences that she experienced for years.

Over many years, I have learned that everything I do nurtures my creative expression. It is not always about time in my studio. Now, as a mother, I find that time is minimal and filled with interruptions. When I did have time, it would be filled with sitting and dreaming or planning and watching. Creativity is nurtured in many different ways. The creative process is not linear, like a complex equation, but rather it's about taking a walk, washing the dishes, folding laundry, sitting in silence for 30 seconds. The mindful attention I bring to each moment of my day as an artist is that fulfillment I experience thinking about and engaging with my art.

Artistic engagement is not about the number of paintings. It is about the intent of painting and the moments that are filled as I experience my life moving forward to that painting process.

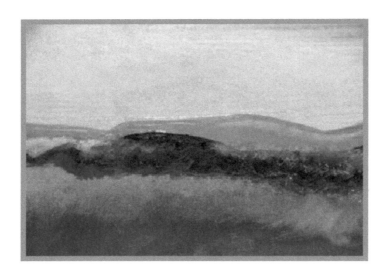

Artwork 3: *Rolling Horizon*, Oils, 2007

In *The Lure of the Local: A Sense of Place in a Multicentered Society* Lucy Lippard defines place in many different ways, from a personal vision of place and feeling centered and belonging, to the broader community concerns that give it meaning and purpose for more than one person. Lippard covers the regional aspects of place as well as community and cultural considerations. She spends considerable time discussing artists' interpretations (of a certain place) such as their emotional reaction to events or the history associated with a place. Near the end of the book, Lippard referred to all places as having stories. The visual artists, she believes are the storytellers who can take the local lore and connect it to what others can see and understood and feel in their lives.

That is how I see my role within landscapes. I am telling my story of my manifestation of self to place and in doing so, I am also interpreting the way I see others in this landscape. I enjoyed Lippard's intelligent use of art pieces and photographic images to illustrate her ideas. Her travels were rooted in the culture and communities where she visited and her representations were from the artists, the locals, who created their work within a place-based context.

Chapter Four – How Place Fits

Soon after moving to Vermont I noticed that there were no morning traffic reports on the radio. I listen to Vermont Public Radio and instead of traffic, there is weather. The weather is given by the "Eye on the Sky" forecaster. The elaborate detail and prose style of this person make the listener get lost in the sense that weather is an unfriendly guest who stops by for a short visit but stays an infinity.

Vermonters are the folk who look to the sky each morning to determine the direction of their day. It is not about deadlines or office politics or getting into work before the boss knows you are late. It is about what that sky tells you for the course of your day.

It could be a blustery cold snow blowing in from Canada that keeps you close to the barn, fueling up the furnace or splitting wood for the stove. It could be an airy May morn that tells you to work in the garden before the afternoon spring showers roll in.

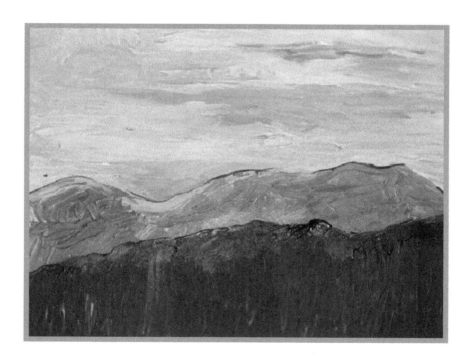

Artwork 4: *Untitled*, **Oils, 2009**

Helen Husher, a Vermont writer, wrote in *A View from Vermont*, "Bad winters---and all winters are bad here----have this compensating goodness, in that we know we are in the grip of something and its squeeze will not be changed by commentary. Understanding this speechless interval is probably a prerequisite for living here." (44-45)

Locals say little, yet demonstrate in action a lot about the weather. They adapt. They prepare starting in August, maybe July, stacking cords of green wood for drying and splitting. After the bad winter passes, then chores are begun. Locals can be seen quietly tackling the roof and foundation repairs and getting their dwellings ready for the next wave of wintry months to arrive.

My first year as a farmhouse owner in Cabot told me I was not prepared. My wood ran out in January. My furnace needed fuel constantly. My second floor had no heat; as most Vermonters know, but I was only learning, old farmhouses only have heat rise up through the stairwells and if lucky, through registers in a bedroom floor. If *you sleep with your bedroom door closed*, I told my teenagers, *you might be frozen by morning*.

After the first winter I began saving small pockets of money for the next winter: for fuel, wood, and insulation for my walls. Eventually I will need new windows. When you see a curtain constantly blowing at the window then that tells you the window must leak a lot of air.

House with History

When I looked for a farmhouse to buy, I had little money. After I left my husband, I actually withdrew my entire retirement account to survive on my own with my children and to buy a house. This house has a past.

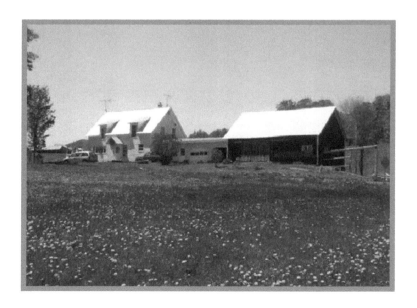

Artwork 5: My Cabot House, 2008

It has past lives that are still connected to it in some interesting ways. I bought this house from the Houston family. When I go into the General Store I just tell people, "I bought Myra Houston's house." And they know immediately which house I am in. It is the yellow house on top of Houston Hill Road, steep and treacherous in winter.

The house is a yellow cape, with an attached mudroom and barn. It looks bigger from the outside than it actually is. Inside rooms are small but cozy. I love my kitchen because it faces east and it has old open shelves.

My attachment to the house was a feeling I experienced as I first walked through it. It was loved. It had a family and it had history and Myra's son, who sold it to me, gave me stories and particulars about the rooms, such as why one bedroom was painted a bright royal blue. "That was my brother's favorite color," David Houston explained.

As my exploration into the purchase became closer, I met David's sister, Dawn, and her family. She showed me pictures from her wedding that took place on the south lawn of the house. I saw Myra, David Sr., and other family members.

While the land suffers, automobiles thrive,

shining as they glide by the thriving towns,

the empty fields bare in winter,

the deserted farmhouses, obstacles merely

to an ideal trajectory from everywhere to anywhere.

—Wendell Berry, "The Shining Ones" from *Leavings: Poems*

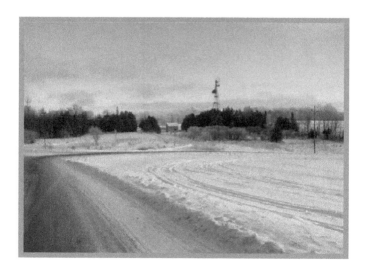

My Cabot Windmill and Pond in distance, Christmas Day 2009

The house has four and a half acres and on it sits a pond with an old broken windmill at its edge. When I bought the place, everything around the house and pond was overgrown, high with weeds. I had someone local cut everything the first couple of months, and the town was so grateful. My pond became the talk of Cabot! In winter, as the ice and snow fell in heaps, my neighbors asked if they could shovel my pond and skate. My two older boys taught young children the art of ice hockey on that pond, and soon it became the town hockey rink. Someone even brought a bench for spectators to sit and cheer.

David Houston told me the story about the south screened in porch. "As children", he explained, "that was our sleeping porch during the hot summer nights. We had many good times out there and often cousins would come join us."

The house sat empty since David's mom, Myra, died, but the family thought the youngest brother, Eric, would buy it. Eric lived out of state and experienced financial problems that caused him to decide against the purchase. I came along the first month the house went for sale by owner. While it needed many repairs, the price was right, and the yellow farmhouse appeal sold me.

My new life in Vermont as a single mom and homeowner began in July 2008.

Life without Measure

In other places where I have lived, I thought life was too measured. There was too much done for us as a society to make life more comfortable. There were too many stores where too much could be bought with too many credit cards and never enough real cash. There was a drive-thru for everything from fast food to dry cleaners. No one needed to park a car and walk anywhere.

Food was packaged and preserved and could almost cook itself in microwave ovens. There was entertainment everywhere, and if there were one silent moment, then children would be screaming of boredom. Everyone had to be entertained, and often it took money and more driving and more entertainment to please yourself after the initial entertainment.

No one could just sit in silence and expect to be happy.

I saw my children as the victims of this immeasurable abuse. I caused this, as did my husband. It served our needs to keep them busy so they would not bother us. So, instead of taking them fishing or camping or letting them roam free outdoors, we bought them more and more toys to entertain them so we would not have to do it.

Adults are the same way with toys. However, our toys can be very expensive and when they break we do not fix them; we throw them away and buy new, more expensive toys. As I embrace a different path in Vermont, I knew my past habits were disturbing and in need of change.

Poet, Wendell Berry, who has written extensively about agrarian societies, explores the differences between a path and a road in his book *The Art of the Commonplace: Agarian Essays*:

> The difference between a path and a road is not only the
>
> obvious one. A path is a little more than a habit that comes
>
> with knowledge of a place. It is a sort of ritual familiarity.
>
> As a form, it is a form of contact with a known landscape. It
>
> is not destructive. It is the perfect adaptation, through
>
> experience and familiarity, of movement to place; it obeys
>
> the natural contours; such obstacles as it meets it goes
>
> around. A road, on the other hand, even the most primitive
>
> road, embodies a resistance with the landscape. Its reason is
>
> not simply the necessity for movement, but haste. Its wish is
>
> to avoid contact with the landscape; it seeks so far as
>
> possible to go over the country, rather than through it, its
>
> aspiration, as we see clearly in our example of the modern
>
> freeway, is to be a bridge; its tendency is to translate place
>
> into space in order to traverse it with the very least effort.
>
> (12)

—Wendell Berry, *The Art of the Commonplace: Agrarian Essays*

Wendell Berry is a poet and author of books about agrarian society. He is a farmer in his homeland of Kentucky and after many years of being away, Berry moved home. He is obstinate about the non-use of technology and how it has changed people to be passive consumers. He sees technology--- from televisions, computers and video equipment to RVs and snowmobiles, as an unnecessary, and zapping the creativity from our lives. He has refused to get a computer at any time in his life.

In 2009 Berry wrote *Bringing It To The Table*, a book about the origins of our food and the value of the family farmers and smaller farms that pay attention to quality and sustainability. He interviewed individual farmers to discover their lifestyle and to highlight the mindful care they paid to their animals and crops. Berry points

out the purpose of his book when he explains "One cannot read this book---or I, anyhow, cannot---without asking how that sort of life escaped us, how it depreciated as a possibility so that we were able to give it up in order, as we thought, to 'improve' ourselves."(58)

With this comment, Berry also looks to Donald Hall, a fellow poet and believer in the agrarian lifestyle. Hall lived for nearly 15 years on his grandparents' small farm in New Hampshire and composed a book about that experience, titled *String Too Short To Be Saved*. Hall looks at the quiet lifestyle and care his grandparents took in maintaining their farm, bringing their own food to the table, and also selling it in their community.

I see the Vermont farmer disappearing from our landscape. In my MFA work, I looked at the work of these local farmers and listened to their stories of survival and daily intentional living. None of their work is glamorous. There are no vacations and not many breaks in the day. Their intent lies in the belief that quality of life and living with purpose is what makes a person authentic and whole. Wendell Berry points out that such farmers do not use unnatural means to solving problems, but rather value

> "…an agriculture using nature, including human
>
> nature, as its measure… On all farms, farmers
>
> would undertake to know responsibly where they
>
> are and 'to consult the genius of the place. They
>
> would ask what nature would be doing if no one
>
> were farming. They would ask what nature would
>
> permit them to do there, and what they could do
>
> there with the least harm to the place and to their
>
> natural and human neighbors…and they would
>
> attend carefully to the response." (8)

bell hooks whose writing has been influenced by Berry, discusses the way the natural world has a purpose and the respect for this that rural folk need to feel and to understand. She writes in *Belonging: Understanding A Culture of Place*:

> Nature was the place of victory. In the natural
>
> environment, everything had its place including humans.
>
> In that environment, everything was likely to be shaped by

the reality of mystery. There dominant culture (the system

of white supremacist capitalist patriarchy) could not wield

absolute power. For in that world, nature was more

powerful. Nothing and no one could completely control

nature. In childhood I experienced a connection between

an unspoiled natural world and a human desire for

freedom. (8)

I understand hooks and Berry. I know how things can change over time. My world growing up had been unspoiled for a short while. The woods that surrounded our rural dwelling was my place of safety. There could be forts, camps, tree houses. The summer evenings were spent playing "kick the can" till our parents called us in. TV was turned off. There were no cell phones to text friends. Music was on the radio or the record player. Then progress moved in. Technology brought us father apart, not closer together.

Even now I wish I could be determined to live a life of non-consumerism and attentive to what nature directs. I am hopeful. I do listen, and I think if I listen more, answers about my life and its authentic engagement in this place will arrive.

The ease of technology has always bothered me. Despite that bothersome feeling, I still conduct most of my teaching and communication via technology. I did not get a cell phone till 2012 and I refuse other devices that regulate our existence and make the sheer possession more of an annoyance than a convenience. At times I find myself stuck in a race of computer-generated discourse at times in my work and my teaching. I see its benefit, but I see the way it destroys the natural conversation between people. We depend upon technology, and when it is missing we complain.

I find it interesting that so many people try to embrace the "simple life" philosophy now. It has become a marketing tool for advertisers, magazines, and those interested in embracing a reformed way of life. Just as Berry, I ask when did we as a society get to a point of expecting conveniences and neglecting the natural beauty of doing simple tasks for ourselves? David E. Shi in *The Simple Life* looks at this philosophy over time in American culture. Shi quotes former President Carter when in 1977, he stated, "In a nation that was proud of hard work, strong families, close-knit communities and our faith in God, too many of us now worship self-indulgence and consumption. Human identity is no longer defined by what one does but by what one owns." (271)

I saw this lifestyle of consumerism invading my family. It was evidenced by me and my husband unable to work in a partnership through a lack of respect for our differences. If we agreed about anything, it was that we never agreed on anything. And our children, the innocent ones, were the ones who had to live within our imposed lifestyle.

So, I took my children to the Northeast frequently. I was ready to move and embrace a different way of life. What I saw on the surface of these trips was only a hint of what was truly there in the depths of this place called Vermont.

A True Vermonter

Part of the joy of my Vermont life and the way the magic strikes me each day as I reflect, is the way I met John Young. He was a Vermonter from The Northeast Kingdom, raised on Burke Mountain. When I met him, he owned a great view of the mountain from his ten acres in East Haven, Vermont.

mountain thunder speaks

hair tingling static as the lightning lashes

is neither word of love nor wisdom

—Gary Snyder, *Mountains and Rivers Without End*

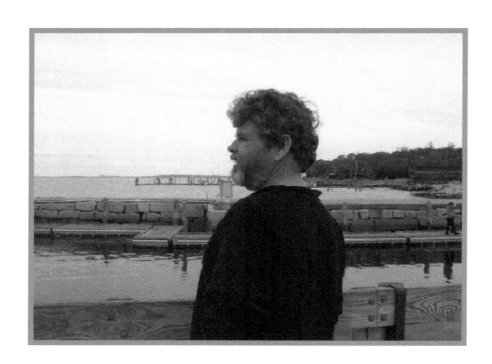

John Young, May 2009

I was not looking to meet a man to fall in love with. I was filing for divorce after a year's separation from my husband, and I knew my life and my children's lives were better farther away from him. I was thrilled to move on despite all the financial obstacles I experienced.

I have practiced yoga for about 23 years and was a yoga instructor for three. When I transitioned to Vermont, I was happy to join the staff at *The Integrative Therapy Institute*, a holistic health center in St. Johnsbury, Vermont. It was started by a Goddard graduate, and it was a lovely spot for me to begin to get acquainted with folks, to teach some yoga for women, and provide some art workshops.

So, it was in March of 2008 that Jean said to me, "I want you to meet our new yoga instructor, John Young. He has just started teaching here." I casually said, "Ok." Then Jean looked at me and said again, "No, I *really* want you to meet John."

I was suspicious.

I did meet John first in his yoga class, but then what followed was magic. There were many chance meetings, mostly in the mornings as I began my drive to Goddard (over an hour one way from where I was renting in Kirby, Vermont at that time). I would stop in East Burke to get my coffee and one of Holly's donuts, warm from her oven with sugar sprinkled all over. The coffee was the best in the Kingdom, freshly brewed and lightly roasted. And there, frequently, I ran into John. He stood there smiling at me with his bright blue eyes sparkling. He had his coffee and donut and there we stood, in the chill of the spring morning, talking outside our trucks until way past the time it was for us to get going.

But that was how it was and how it remained with John. It was chance, serendipity, magic. It was that relationship I never thought I would have but did not hesitate to welcome. It was the unexpected. It was joy and happiness and tears and remorse all channeling though my life in less than two years.

I was deeply in love.

John was a remarkable soul-mate and I loved sharing time with him. Our childhood years and early adult years could not have been more different. John lived the life of the Vermonter that was filled with hard work, outdoor escapes and the meaning of doing everything for himself. John never bought anything new. He could hunt for any item in a yard sale, fix it or remodel it and turn it into perfection. John brought new vision into my work. I gained both knowledge and respect for the life he had growing up, and for that life I learned to listen, as I journeyed around Vermont.

John once told me a story about getting his son, Gabe, ready for fishing, many years ago, when Gabe was six. It was in April and the start of the fishing season and it was the excitement of getting out---finally----out of the ice and the snow to enjoy the newness of spring. As John put it, "We had toughened out winter…"

Loving John was the feeling of toughening out winter, awakening to the open sky of spring, welcoming the warmth of summer and praising the beauty of the fall. It was cyclical and ever changing and being prepared for the worst. My relationship with John was about healing our pasts together, greeting the present and only imagining the splendor of a future.

It was the essence of Vermont and my relationship with place that I saw in John. It was the challenge of the storms, the daily unpredictability of the sky, the changes in the wind and temperatures, the drifts of snow that block windows and doors and the common sense it takes to meet these challenges and survive to spring and then into summer.

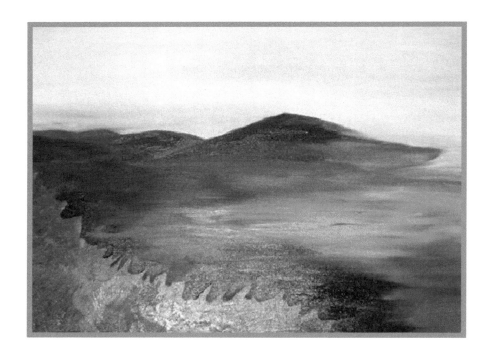

Artwork 6: *Rising*, Oils, 2007

Chapter Five — My Artistic Place-Based Practice

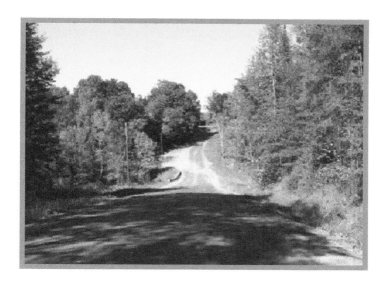

Ridge Road in Kirby, Vermont, **Early Fall 2007**

Much of my artistic practice comes from reflection and knowledge in growing older and more respectful of the importance of time. I see all parts of my life weaving the fabric of my practice. This includes my yoga, my meditation, my children's lives all crossing and intersecting and sometimes colliding. It can come to a crescendo of sounds and images, but the composition is always mine.

I try to look outside myself to gather inspiration for working within myself. The outside world consists of the study of place, but more than that, it encompasses the world as I see it in the present. For me it is about culture, landscape, social norms, ordinary people and the interactions of life within a setting. I look within the creases of life and the intersection of emotion in the context of landscape.

Within the work I do I try to create stories through the use of different media, although the most predominant medium is paint. I work on wood, masonite, canvas and paper. My images reflect the reality of the landscape but move forward onto abstraction. My most recent work is created out of paper, paint, maps and reflects collage construction.

Often when I paint, I apply it in thick, textural, gestural waves of color and I frequently mix colors right on the surface. I use knives as well as brushes or my hands. Images I create are from my interactions with land, spaces, people and their spaces and from the stories I hear about place. I take many photographs and work from those images as well as the collection of images in my mind.

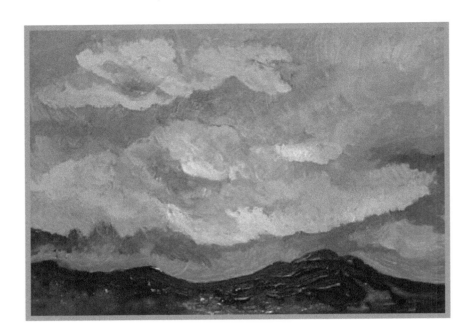

Artwork 7: *Storm Rolling In*, **Oils on Masonite, 2009**

I take my work with me wherever I go, and I look seriously at the differences in places that I encounter. I try to find the balance and the beauty within each place, and I listen to the voices of those who live in the spaces daily. I embrace the knowledge of those who exist in the spaces I study.

Part of this rich study of landscapes comes from studying the drawings of land in the form of maps. Edward S. Casey has examined the way artists interpret land mass and the uses of different kinds of mapping. Casey explains "mapping in" as the way a map is interpreted to reflect the way a place makes someone feel when they arrive. "Mapping out" refers to the understanding of life as a part of that living landscape. (p 12)

This knowledge made me begin to work with maps in a singular and imaginative way. The wood panels I used became pieces of a transitional art form. I glued the maps then painted around them, over them, then glued more maps then painted more. The process was similar to traveling with a backpack in and out of a rough terrain.

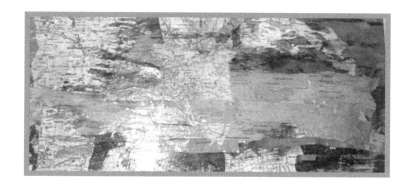

Artwork 8: *Integration*, maps and acrylics and mixed media, 2009

For many years, my artistic practice was identified more with drawings and black and white collage-like compositions. Both in college and in New York City at the Art Students League I was taught to develop a loose, gestural drawing style. From my early figurative pieces to the present landscapes today that sense of line and its fluid, feminine capacity has always remained with me.

I studied under two masters in figurative work at the Art Students League: GustavRehberger and Anthony Palumbo. Both drawing masters taught me proportion and the intuitive feeling of form through a capturing of rapid line and movement. My Rhode Island School of Design instructor, Mahler Ryder, allowed me to move forward to create greater collage compositions using pieces of figures and more contrast in the lights and darks.

My early work taught me discipline and structure as well as flexibility and strength in the line. Within the classical teachings of art, there comes a centering. There is also predictability to the method, which can discourage many young artists yet comfort those who move beyond. As I teach art today, I find I move my students from the defined form as they learn to see and capture a sense of what they see; I then move them towards a freedom within form and interpretation.

The study of anatomy is critical for this pursuit. It is agonizing for young artists, but it forms the foundation for the later figure form and the exploitation of the figure within an abstract or non-representational context.

The following pages reflect the early training I had within figurative art. I think the resemblance to my landscapes may be clear.

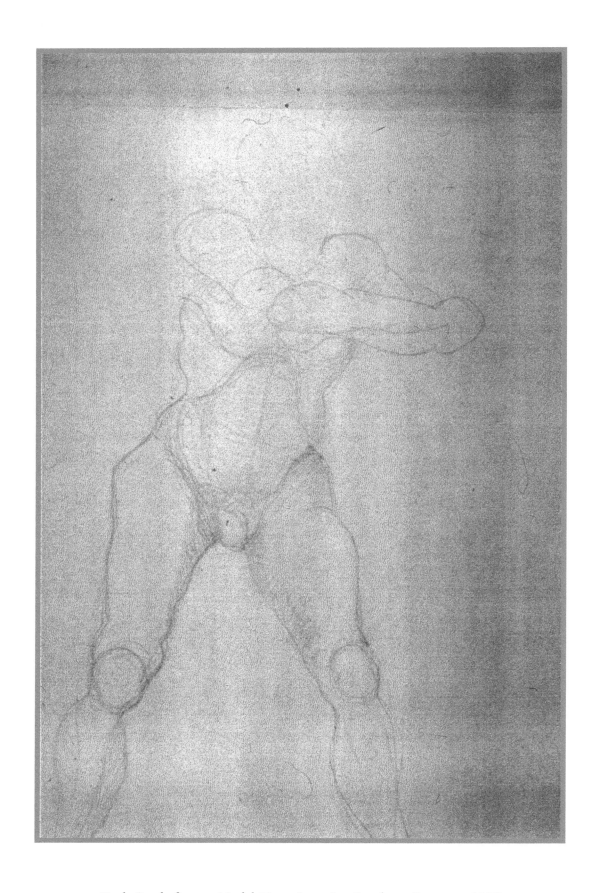

Early Study from a Model, **Drawing, Art Students League, 1976**

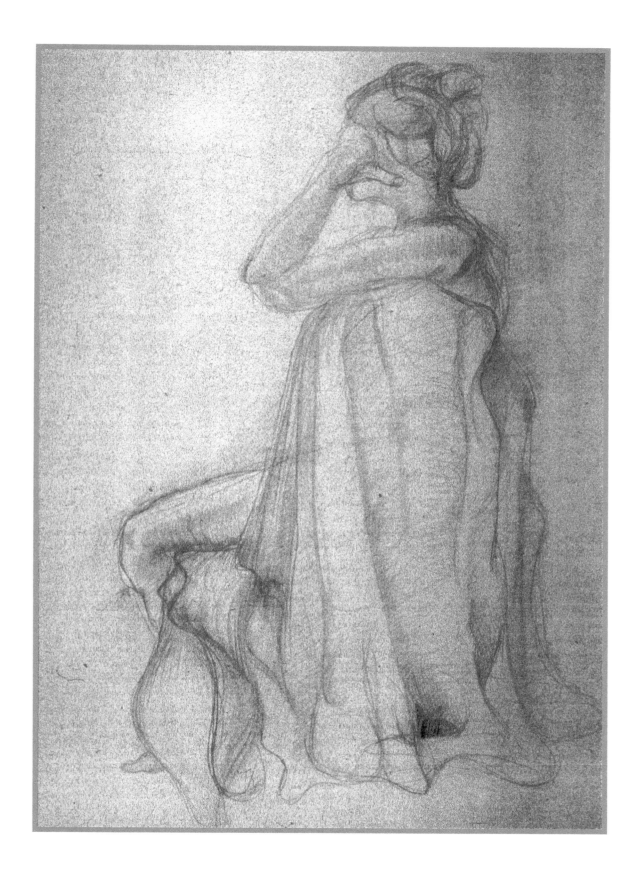

Study from a Nude, **Drawing, College Work, 1975**

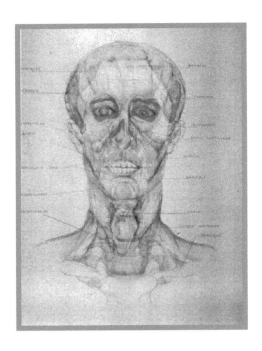

Anatomy Study, **Drawing on acetate overlays, during college, 1974**

Early Collage of Figures, **Drawing, Rhode Island School of Design, 1979**

I see how my former figurative work influences my current work within landscapes. I try to capture the sensuous, female form of the mountain, the rise and fall of the valleys, and the transition of line now with color, as one moves past the other and waves. As Edward Casey says, "Like flesh, landscape is the living and lived surface of a body---the earth's body."(p 142) In general, Casey sees the landscape as being represented in a variety of ways that can interconnect with one another. In his view, maps and paintings are intertwined, with both contributing to ways that people understand and see their world.

Casey also examines the work of Willem de Kooning and his work created early in his career. De Kooning was known to integrate or blur the distinction between woman and his landscapes. Casey wrote about de Kooning's work, "Rarely, has such a degree of interfusion of one with the other been achieved." (143) It seems that de Kooning used the landscape to move his figures in and out of the composition. Below is an example of his abstract expressionism that made Willem de Kooning famous.

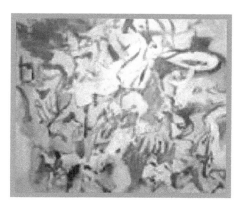

Willem de Kooning, *Figures in a Landscape*, **Oil on Paper, undated**

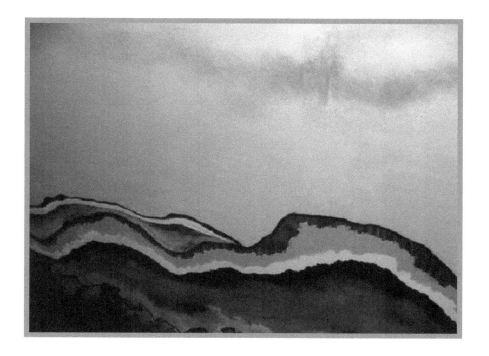

Artwork 9: Portion, *Journey Over the Mountains*, **Acrylic Painting 2010**

For me, landscapes can symbolize journey and the movement of the human figure. My most recent landscapes capture my fascination with mountains, fog and the simplicity of the lines along the horizon. Often tree lines, many become a bit bare when the autumn foliage starts to drop. I am fascinated by how this landscape changes daily.

Possibly my painting could go on forever with only mountains and fog. I could see that happening. There are endless possibilities of color, light, texture, and forms to be created. I experiment with different size canvases, too.

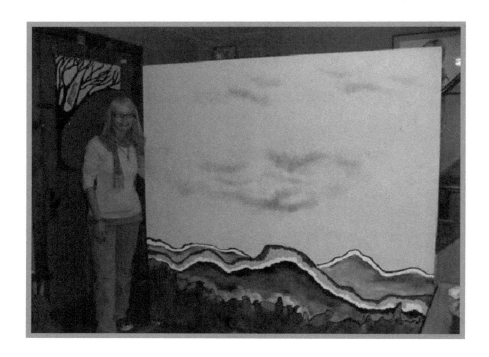

Artwork 10: Entire Size, *Journey Over the Mountains*, Acrylic Painting, 2010

My work is most influenced by the colors used by Wolf Kahn and Emily Carr, the mountainous images depicted by the Canadian Seven, the words on place and culture by bell hooks and the storytelling of poets David Budbill, Baron Wormser, Wendell Berry and Donald Hall. Other poets I turn to for visual imagery include Daniel Lusk, Matsuo Basho and Gary Snyder.

My attachment to Wolf Kahn reflects his involvement with the Vermont landscape and his particular choices of form and color. There is a progression, as with all artists, to the point where his landscapes embrace the barn motifs. His style moved from the expressionistic and often non-representational (tonal painting) to the pure, soft color of his horizontal rural landscapes.

These changes in style came when Kahn moved to Vermont in the 60s. Before that he traveled often to the Cape and specifically to Provincetown and Martha's Vineyard to paint. When Kahn bought his farm in Vermont, his style moved to the barn and the impressionistic translation of color onto the canvas.

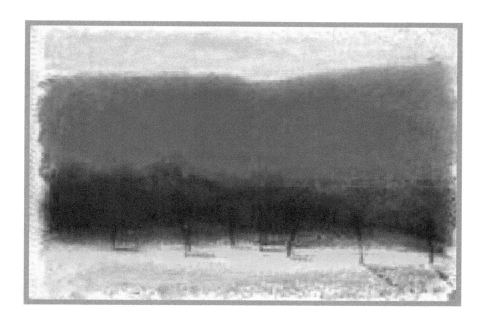

Artwork 11: Wolf Kahn, *Blue Hills*

I have been impressed with Kahn's style for a few years now. I see a command of color and purity that I often attempt in my work. Several years ago, I painted a series of oil works, all rather small, focusing on the concept of tonal painting. I imagined the canvas to be open for a vision of empty color transformation. I began to peel off the whiteness and add on new layers of depth through color application, not concerning myself with subject as much as with process and motion.

From that point, I felt cleansed and ready to return to a subject again. There is something so pure about the natural world and those images and forms that surround us daily. I can see why artists turn to landscapes. I am intrigued by the simplicity and clarity and the presence of mind I have as I paint now.

Chapter Six — Art in the Hills

Each day identified itself as a passage to elsewhere,

which was a passage to elsewhere and to elsewhere.

—Donald Hall, *The Painted Bed: Poems*

My time as an artist in these mountains of Vermont has been about growth and openness. I open myself to the idiosyncratic manners of a people who are rooted in their land, in their small villages and their familial relationships. I am getting to know a singular culture built on both survivalist and independent means, saturated in some communities by poverty and alcoholism, and the passage from one long winter to the next.

I love my life here and I always knew I would.

Yet, I have concern about the lack of racial diversity throughout the state. I wonder why that is and how that will affect my two children who are black. They love Vermont, but they also do not see a mirrored self here. I worry over their identity issues and how I can compensate for a lack of role models.

I hope it changes as they grow up here in Vermont.

My daughter Rachel in the rural school at Cabot

As I root myself and my children in this predominantly white, rural countryside, I am aware of how it affects me to integrate into community. I see the barriers from the perception others form of a white mother on the hill with five children---two black young ones, two white teenagers and one growing up son in college. For over a year they saw my Vermont partner, a man who was disabled from illness yet who worked the garden and around the house with regularity. The neighbors and residents in the village ask few if any questions. They complain about my old dog, threaten to shoot my cats who roam and hunt and frequently, and some folks give me odd looks when the fancy strikes them.

However, I am learning to be myself. Maybe that will help my children be who they are.

> The strongest lesson I can teach my son is the same lesson I
>
> teach my daughter: how to be who he wishes to be for
>
> himself. And the best way I can do this is to be who I am
>
> and hope that he will learn from this not how to be me,
>
> which is not possible, but how to be himself. And this
>
> means how to move to that voice from within himself,
>
> rather than to those raucous, persuasive, or threatening
>
> voices from outside, pressuring him to be what the world
>
> wants him to be. (77)

—Audre Lorde, *Sister Outsider*

I am learning that art sits at my core more than any other trait I possess, and I am growing proud of the richness that this life is teaching me. That Vermont independence is strikingly appealing to me, despite my identity as a flatlander.

Chapter Seven — How to Love Being a Flatlander

If you are not born in Vermont, then you are a flatlander. The term has implications for anyone who moves in and maintains a home or a second home here. Often that means New Yorkers who have a particular image in the eyes of Vermonters. That New York image brings wealth, status and money into this state. It does not mean the flatlander is actually *from* New York. It refers to the image of that New Yorker who brings a disruption to the original landscape. Some migrate and build new, expensive homes.

Backroad in Burke, Vermont, 2008

Artwork 12: *Side to Burke Mountain*, Oils, 2007

This invasiveness of the landscape is seen in the ski areas. I felt the ominous presence of outsiders in the area where I rented near Burke Mountain in the Northeast Kingdom when I first arrived. A corporation had moved in, bought the mountainside, and begun building condominiums. Their profit margin was high. Many flatlanders swarmed the mountain for their winter homes, strategically built near the ski lodge. Their pocketbooks were deep and their interest in the preservation of the local culture was distant, as distant as their incentive to preserve dignity and fairness in their relationship to the land itself. Many people moved in for the convenience and the enjoyment of sport and social activities held within that newly built community on the mountain.

It made the locals crazy. They fought the corporation's move inside their space but in the end, the battle was lost on Burke Mountain and the flatlanders won, just as they had earlier won their rights to Killington and Stowe Resorts. Those mountaintops are now covered with an entire city of condos, second homes and resorts that feature seasonal wedding packages at enormously high prices. Imagine the thrill of getting married on a mountaintop surrounded by the luxury of wealth and the obscenity of rich foods and glamour. What more could a flatlander ask for?

As I deliberated on these painful realities of the Vermont landscape, I found my work changing. No longer were my colors smoothly applied to the canvases I carefully stretched and primed by hand. Suddenly my work took on the thrashing of the mountainside where I lived. I worked on masonite or on canvas paper applied to the masonite. I worked with smaller sizes and took the oils mixed with acrylics and applied colors in a demonstrably heavier manner with palette knives or my hands. I worked rapidly. I continued my reflection on the landscape but I felt the energy within me shift.

Artwork 13: *April Sun Setting*, Oils, 2008

My work became abstract and distorted, often intentionally pushing out the reality of the war on the mountains. I felt a communion with the locals in East and West Burke and Kirby where they fought as hard as they could to keep away the wealthy land grabbers. Do we ever draw a line where money is concerned? Are we ever able to say, *No, this is enough*. What is the price of preservation versus expansion, exploitation and development?

How do we want Vermont to be remembered?

Artwork 14: *April Mountain*, Oils, 2008

When I first saw Vermont, around 22 years ago, I was afraid of the mountains. I felt suffocated. I was a passenger in a car and I think the rolling hills were contributing to nausea and upset in my stomach and I could not imagine living in a place where there seemed to be no escape. Now I realize that these mountains provide the escape from the rest of civilization and the corruption of land outside these hills. Why would Vermonters want flatlanders to settle in their state if they knew the price of their decision?

For ten miles the mountains rise

Above the lake. The beauty

of water and mountain is

Impossible to describe.

In the glow of evening

A traveler sits in front

Of an inn, sipping wine.

The moon shines above a

Little bridge and a single

Fisherman. Around the farm

A bamboo fence descends to

The water. I chat with an

Old man about work and crops.

Maybe, when the years have come

When I can lay aside my

Cap and robe of office,

I can take a little boat

And come back to this place.

—Chu Hsi

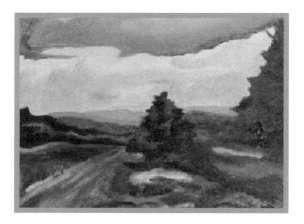

Artwork 15: *Vermont Farming*, **Oils, 2007**

Chapter Eight — The Farm

I moved into my third semester of my MFA graduate program with intent to develop my practicum. I began to think more concretely about the individuals most affected by the landscape, the farmers, whether they were land growers or dairy or meat farmers. I began my journey by talking with them and then documenting what stories I heard.

I can say that the experience of talking with these farmers provided me with a perspective on choices that people make as they interact daily with the land in Vermont. I was able to sense the enthusiasm that farmers have about their work despite the long, difficult days of independent struggles. An excerpt from my Practicum reads:

"The best day on a farm is a day when nothing goes wrong."

 Paul Stecker, Maple Lane Farm, Cabot, Vermont

> The Steckers knew about the Cabot place and began to
>
> pursue it. They were shocked at the amount of work ahead
>
> of them. They worked constantly on propping up the barn
>
> and repairing the cupola. They remodeled the house and in
>
> the process, after removing piles of junk from its backyard,
>
> they even uncovered a pond.

Wendell Berry wrote *Imagination in Place* as a response to his own life as a farmer and as a poet. He discusses the perspectives of different poets who reflect on Place within their written word. Berry talks about John Haines and the power that Haines had to "unite experience, history and dream…"(52) "I think there is a spirit of place, a presence asking to be expressed; and sometimes when we are lucky as writers, and quiet in a way few of us want to be anymore, a voice enters our own…"(52)

Berry sees Haines, as well as other writers as demonstrating their love of not just one place but a connection throughout a community. The writer's job is to bring the art and the community together in a voice that expresses creativity and passion and a love of what we hold dear in our lives.

Gary Snyder brings these images of place and his poetry of travel and mountains into his *Mountains and Rivers Without End*. This book of poems is about a journey, the passage of a self walking tirelessly on a path.

> Walking on walking
>
> Under foot earth turns
>
> Streams and mountains never stay the same
>
> —Gary Snyder, *Mountains and Rivers Without End*

As a Buddhist writer, Snyder's belief of impermanence resonates throughout his work. His sentences are a tower of words, reflective of a capacity for image-making. Images are accumulated and thrown free. It provides a lack of structure for the reader but does allow for many images and interpretations to be formed.

I see my paintings as images that are collected over time from my experiences and my feelings colliding. There is not just one landscape in each frame but instead, a collection of many views from many mountainsides. A Haitian proverb puts it very well, "beyond the mountains, more mountains".

It is that connection to the farms and to homesteads and land that I feel deep inside, as I close my eyes. It is not about the exactness of what I see but rather the feeling I have *after* I see it. I described this experience in my third semester in my program:

> Today I was driving my seven and a half year old daughter,
>
> Rachel, along Route 2 East in Vermont around 3:30 pm.
>
> We hit the area just past Marty's Store in Danville as the
>
> road slopes upward and St Johnsbury becomes in
>
> measurable sight. It was an "AHA" moment! I turned to
>
> Rachel and said, "This is why Mommy always wanted you
>
> to grow up in Vermont."
>
> The view of the White Mountains becomes visible at that
>
> point on Route 2. It is always, always breathtaking. The
>
> cascading slopes feel like the warmth of an old friend seen
>
> after a long journey, someone waiting to embrace me.

Although it is February and cold temperatures create white icy patches, there is a kindness to those mountains. They smile. They are very old and they have survived transitions in weather, human interventions, and natural disasters.

Those mountains are much stronger than I am. That is why I turn to these mountains for strength each day. Whatever goddess is out there I am convinced that she lives in these mountains.

Chapter Nine — Developing an Intentional Practice

My work is not about a landscape painting. It is about a *story*. My work is generated what is inside me and my feelings about place, specifically focused now on this place called Vermont.

I do not do plan a painting. Instead I walk, I drive, I sit, I take pictures, both in my mind and on film, of place, and then reflect and internalize what it means to me. The emotion of place is more real for me than the image of place. My images result from the affective attachment I have with this place.

Further, my paintings originate from a sense of Self that I bring into this Place. I feel called to Vermont. I believe in the ethics and lack of ethics of the culture, the humanity in its raw sense, the vision that intentional hard work brings to the lives of these communities.

Artwork 16: *Evolution of Place*, **Oils, 2007**

It is within this paint and in and around and through my sense of self as an artist, as a mother, a teacher and a companion that I find my creativity. It is through the intentionality of a daily interaction with place that I evolve. It is through the breaking of those boundaries of self that I can truly emerge.

The sense of Self that I pursue is never a completed journey. It is a daily practice much like my yoga as I sit in stillness on my mat in the morning or bend forward in a humble way in the afternoon. It is the surya namaskara of the asana, the salute to the morning sun, to the mountains, to the deep low valleys. My shadow is cast and the intention I keep may last a moment until I find my next breath in the landscape before me.

There is a flow to my breath as there is to these mountains.

Rolling in. Rolling out.

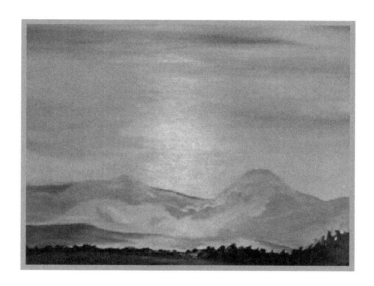

Artwork 17: *Grey Rolling In To Meet The Purple*, Oils, 2007

The sensation of beauty that we are capable of creating as artists each day with our lives should be the intent that keeps us humane, compassionate and connected to our families, our communities and our discipline. We can demonstrate our compassion through our actions and by surrounding ourselves with the positive energy in the land.

Chapter Ten — Building Family

I am blessed with five children who share my love of creative expression. My children teach me patience in daily life. They teach me not to sweat the small stuff, to remain optimistic, to open my heart to others, including cats, and to learn to bridge my love of landscape in with our sense of family and home.

I create art in and around my home. My children are often integrated into the current visual projects. I created *Building Blocks* from a leftover apple crate, and small chunks of wood from my house reconstruction project.

Artwork 18: Building Blocks, Wood, Collage and Acrylics, 2009

Building Blocks is a collage and painted project that covers my adult life from my high school dating to my current Vermont life. In and around this crate sit the people I most care about. The pieces are to be touch, examined, and held.

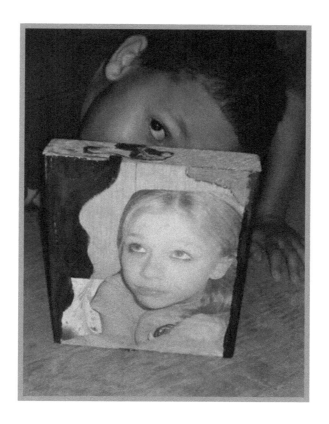

Artwork 19 Erik peering behind one of the Building Blocks, 2009

Christopher is my oldest son. He attends Goddard College, integrating as much filmmaking into his liberal arts studies as he can. His art is behind the camera and editing is his favorite pastime, well, when he is not on the ice playing hockey.

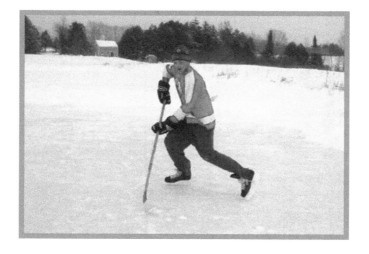

Chris practicing on our Cabot property pond, 2010

Christopher has grown up surrounded by my art. I would make art anywhere, on the floor of my bedroom, on our kitchen counters, tables, and the floor. Wet paintings would be drying in the bathroom. Once I went slightly crazy with our cats because they ran across my wet paintings, leaving painted paw prints throughout the house.

Chris getting his work done in the middle of my paints.

Ben is my old soul. He is quiet, pensive, deep, and intellectual along with very creative and connected to the environmental world. He has many layers. His sister, Mary Katherine, often called Molly by her family, is my child who is my regulator. She sends me her wisdom through her face, its beauty and its compassion, its angst, and its inquiry. She asks the hard questions and she sees the world in the way a teenage girl should see it, filled with drama, too many boys, best girlfriends and total engagement in the moment.

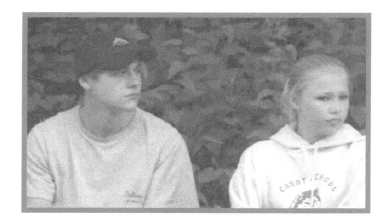

Ben and Molly at the Cabot 4ᵗʰ of July Parade, 2009

Both Ben and Molly know how I value my creative engagement. Molly was named after her great-grandmother from Putney, Vermont, Mollie Butler Plowden. My Molly grew up next to me when I taught her peers in my Ohio studio and ran my Summer Art Camps. She was my helper and my organizer of art supplies. Ben began painting next to me at age two while I was on pregnancy bed rest with Molly. Ben said nothing each day as he took every color and created masterpieces, in his quiet way. Both Molly and Ben are gifted young artists today. Ben is excellent with details of portraits and still life compositions while Mary loves to draw in black and white and paint extraordinary watercolors.

Erik is my extreme sports 7 year-old. I fully expect many emergency room visits throughout his lifetime. Erik runs faster, climbs higher, and can scale any doorway in his stocking feet. I have seen him go find tools, take off his own bicycle training wheels and later, in the same day, ride the two wheel bike so fast that he had to jump from it before it landed in the pond.

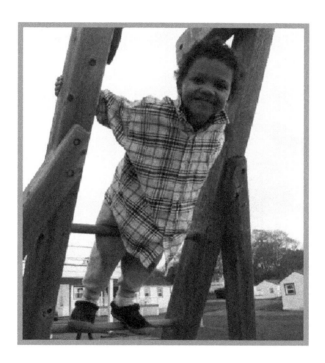

Erik in Maine, 2009

Rachel is my stabilizer. She makes me find the structure in my unstructured life. Without structure, Rachel falls apart and with structure, I know I can be there for her to meet her emotional needs. I once told her, as we struggled with her ethnic hair, that everyone will know she has a white mother when they look at her hair.

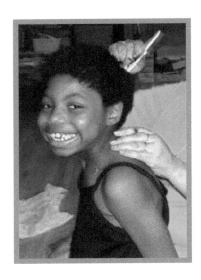

Rachel getting her hair done with Sylvia, 2008

My two youngest children, Erik and Rachel, are adopted. I am willing to share their stories of love passed on from my experiences with their births in our open adoption arrangements.

Erik lost his birth father in December 2008 to a kidney disease that took the life of this young 30-year-old from Columbus, Ohio. We hold memories of Joe as a fun-seeking, humorous, total risk-taker. I see those qualities in my son, Erik.

My daughter Rachel lost her birth mother in February 2009 to a massive seizure that sent her into a coma then to her passing. Adriane was 33 years old and living between Milwaukee and Chicago.

The love of these birth parents cannot be adequately expressed in words. They were able to look outside their own desires and seek a better life for their children. I hold great respect, admiration and unconditional love for both Adriane and Joe. My stages of grieving for their loss made me wonder about the way my artistic practice could facilitate the healing. I have passages I've written about the trip I took with both of my daughters, Molly and Rachel, in August of 2009 to return to Milwaukee, Rachel's place of birth.

In addition to the written memoir, I created some collage pieces that reflected my daughter's birth, her birthmother's courage and the sense of family bonds I knew were important. I saw these roots as extremely important for Rachel in her identity and her development into a young black woman. She needs those birth family members to help complete her sense of womanhood within the context of race and origin. I describe this need in the memoir *"How Two Mothers Met"*:

Acceptance

The night before I left I sat in Jean's living room. Fans had been going full speed all day. It was hot and humid and my clothes were beginning to stick to my body. I laughed at the way Jean bantered back and forth with Val. I could hear Adriane in this conversation, too. I knew she could throw herself into a dramatic scene.

Laughing, I said to Jean, "I feel like I am right at home." Jean replied, "I know. It feels familiar to have you here like you always had been here."

That is when I knew I would return, maybe often. It had started as a trip for Rachel but it had transitioned into a trip for me, too. My sense of family, forgiveness and acceptance all intersected in a wise and wonderful way.

I knew my whiteness did not change. Their blackness did not change either. Yet my voice of motherhood, sisterhood and the greater sense of belonging that I felt was more of a reality than color and separation.

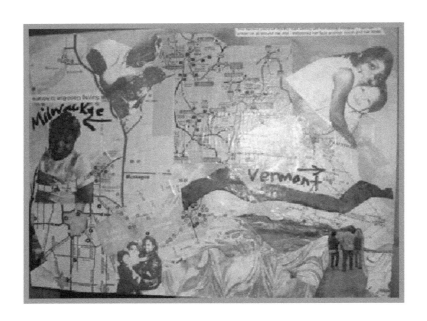

Artwork 20: *The Journey,* **Collage Composition, 2009**

Saying Good-Bye to Adriane

The hardest piece of this trip was seeing yet not seeing Adriane. I felt her presence all around me and I welcomed her face and her touch and her smile. Yet the reality was that this presence was not her. It was the image of a woman raised by Jean, sistered by Val and Janea and parented by many others who were there: Derrick and his children, Dave and Catherine Rose, Antoine, Jean's sister and Larry, Merritt and Merritt Jr, Rudy, David and Nathanial, Tyrone and Joe, her brothers.

I left Milwaukee with Jean, Val and Adriane's son, Tyrone at the ferry gate. We said "good-byes" but I knew it was not forever. I cried as I saw the three standing

there waving. I blew kisses as I always did with my
children when I sent them off to school. I walked away
with Rachel and Molly. As I rubbed Rachel's back and
told her we would return, I knew that I held onto a piece
of my dear friend, Rachel's birthmother, who lives on in
this beautiful girl.

A true home is the place----any place--- where growth is nurtured, where there is constancy. As much as change is always happening whether we want it to or not, there is still a need we have for constancy. Our first home is the earth, and it will be where we come to rest forever, our final homeplace. (68)

bell hooks *Belonging: A Culture of Place*

Two other collage pieces evolved following the journey. Both are addressing topics of family, migration, sense of birth and identity within place. Both works began as paintings and then transitioned into these mixed media compositions.

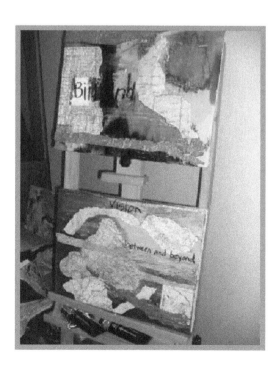

Artwork 21: *Birthing and Vision*, **both Mixed Media Collage, 2009**

The sense of Migration is not new to art. One of my favorite painters, Jacob Lawrence, examined this topic closely in his work called *The Migration Series*. Lawrence was an African-American painter from Harlem. His work was as a storyteller. He tells the story of the migration of rural southern blacks to the industrialized north where they came for the promise of work in cities. His paintings are large and colorful, abstract in their figure representation but realistic in their story lines.

Lawrence teaches the sense of identity that comes from landing in certain places. It is all about purpose, integrity and a personal sense of self that develops from the stories he tells in pictures. The *Migration Series* describes the first wave of blacks into the north from 1916-1919.

Lawrence is able to demonstrate the harsh realities of moving away from a farming lifestyle that blacks knew (some of our first farmers) to the harsh urban sprawl that awaited them after World War I. The blacks who boarded trains and moved north were faced with a need to find their own way as they sought work in the city and education for their children. In this quest, they encountered segregation, discrimination, and crowded living conditions Lawrence painted panel after panel of these stories, some much more painful to see than others.

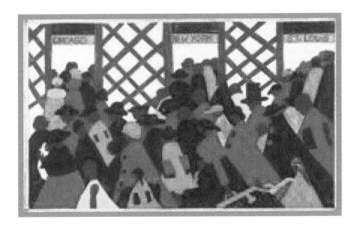

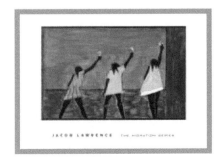

Two of Jacob Lawrence's Paintings from *The Migration Series*.

The highest good is like water.

Water gives life to the ten thousand things and does not strive.

It flows in places men reject and so is like the Tao.

In dwelling, be close to the land.

In meditation, go deep in the heart.

In dealing with others, be gentle and kind.

In speech, be true.

In ruling, be just.

In daily life, be competent.

In action, be aware of the time and the season.

No fight: no blame.

From *Tao Te Ching*

Migration is intentional. It is about a journey and finding home.

There are circumstances, life events, and transitional elements from past and present that influence choices. Just as the African Americans left farms and roots in the south to migrate to northern realities that they only imagined for themselves, I too moved my family to this new state. This Vermont looked very different from my original Mid-Western roots. The message within my soul spoke of layered themes: surrender, passages, responsible choices and dedicated unions. The effect on my work was profound: images emerged of mountains undulating throughout their horizons and moving into a divine marriage with sky and earth.

Other effects could be seen in my migration: my children each adapted and found their sense of self within school and community spaces. In the fall of 2009, I wrote a "fictional" narrative piece in three parts. Each part was spoken in the first person by a different member of a family. This family had migrated to Vermont from Ohio. It resembled the family I knew; it had familiar traits and yet some disguises. The first one who speaks is Abagail, a 14 year old, who is bright, bold, and honest in her early adolescent yearnings. Abagail searches for meanings to her absurd eighth grade existence and she tries to come to grips with why her mom moved their family to "cheese town." The title of this narrative is "There is not much Room Between the Nerds and the Weirdoes or Everybody's in my Business." Here is an excerpt:

Eighth Grade in Cheese Town

You see I am 14 years old. I am in eighth grade. I live in Vermont in a town known for its cheese. Kids call my brother "cheese boy". He hates that. I have lived here for a year and in Vermont for two years. I like Vermont although my friends back in Ohio are not sure where it is. They are stupid. I wanted them to visit me but now I doubt that will happen. They know nothing about geography.

Ohio seems like a long time ago. My mom and dad divorced and my mom moved here with my two older brothers my younger sister and me. My mom and dad both are crazy. My mom's a hippie and my dad's a Republican. I am not sure how they met or why they ever married.

But that is another story.

I am stuck here in this little Vermont town with no escape. I thought seventh grade was awful. Our 7th and 8th grade classes are together and the 8th graders last year were horrible kids. I mean they really talked behind my back, gossiped, got in my face and ALWAYS got into my business.

It was sick.

I cried a lot. I tried to get away from the girls who were always harassing me but they seemed to find me. I think

they were stalking me. They were bossy, rude and immature

Now, I still see them. They are now in ninth grade and well, this school is so small that I cannot completely avoid them. They are pretty crazy, let me tell you. Now I just have my class. The boys are only half crazy, some are actually ok.

But then there are the new seventh graders. Oh god, where do I start.

I am gonna tell you a story. It was the third day of school this year and our first full, real day of some work.

The eighth graders were supposed to do a team project by pairing up with a seventh grader. It was one of those getting to know you exercises. Mostly, I hate those because I feel like the kid getting to know me never really knows me. What's the point?

So we walk to the seventh grade area in our classroom. The entire class is composed of either nerds or wierdos. I think to myself, "Should I chose a nerd or a wierdo?" Then I realized that all the nerds were taken so I was stuck with a wierdo. Great.

I looked over the kids. For some reason and I regret it to this day, I went up to Carly. She is definitely the weirdest creature in that class. She looks like the size of a second grader, has hair that has never been brushed,

and she talks all the time, about nothing, absolutely nothing.

I was trapped in her web. I knew it and I could not escape.

I sat there as Carly droned on about things in her life that made no sense to me. She was thrilled that I picked her. Now to this day she considers me her best friend.

Nobody likes her. I guess I do feel bad for her but really she is crazy. She talks about nothing and she tells these jokes that make no sense. When she told me the joke about the cats and dogs I thought it was me and I could not get it. Why was it funny? Then all the kids sitting behind us said to me, "Don't let Carly tell you a joke. They make no sense."

It is not me.

No one understands her. And Carly talks all the time.

Do you know what I mean? She is one of these people who says something all the time but has nothing to say. Now I am stuck with this strange bizarre girl. She seeks me out all the time. No one will pay attention to her and since I chose her for the first day activity, she thinks I like her and I'm her friend. How awkward is that?

Other kids ask me, "Are you Carly's friend?" I don't want to say "No" because that is so hurtful yet now I am

getting labeled, too. "Carly's friend. Carly the wierdo has a FRIEND!"

Why do kids TALK so much?

Why do they have to talk about me or about others?

I just do not get it. In other schools I have been in, I saw these issues, too, but here in this wicked small town, I think it is much, much worse. I think these kids in middle school do not have a life. There is nothing to do.

So what if Carly is my friend? That is my problem, right? Yeah, she annoys the crap out of me. Most of the time I do not know what she is talking about. Then she stops and asks me a question and I have to say, "Carly, I do not know what you are talking about." Well, that is WORSE because she starts the story all over again.

ARUGGGH!

Carly is not the most annoying person in middle school.

I seem to attract the wierdos. Kevin was assigned to my Social Studies project group. Well, lucky me because Kevin is this little creep who never does his work, has nothing to contribute and he constantly complains about nothing at all.

Last Friday, John, the other person in our group, was absent. Oh great, I thought, it's Kevin and me working ALONE on the project. Just as I expected, Kevin did

not do his homework for our group. He had nothing. I told him to talk to Mr. Everett, our teacher. I overheard the whole conversation. Kevin trying to explain his excuses to Mr. Everett and Mr. Everett actually was being almost sympathetic and listening to this creature. I could not take it. I started staring them down, mostly Kevin. I did my "evil eye" thing, as my mom calls it. I gave Kevin this evil eye. Well, of course, Mr. Everett saw it. I guess I felt embarrassed but not TOO embarrassed. This creep did not do his work so our group might get a bad grade.

Mr Everett came over to me. He said, "Abagail, what was that? What was that evil eye?"

Oh god, he actually called it an evil eye, like my mom calls it!

Now I was embarrassed.

Okay, I told Mr. Everett. "Kevin did not do his work. John is sick and now our group is really far behind." Mr. Everett assured me that Kevin will be graded on his own participation.

Ok. Fine, but what do we do in class without his work. I was too scared to ask Mr. Everett that question but it was on my mind.

Lots of things are on my mind.

To name a few:

How could I be stuck with so many immature people everyday?

Where do I fit in?

Why is my life so crazy at this school and all kids have to do is gossip and get into my business?

Does my mother KNOW how much I hate it?

Will I have to go to high school at this place where no one likes me and thinks I associate with wierdos?

I think my big problem in cheese-town is that kids do not leave here. They seem to be happy with that. I love to visit other places and get to know other people but kids here are happy with staying in cheese-town forever.

That bothers me.

I have no specific goals for my life after school except to travel. I want to go everywhere, like my friend, Anna, who is 22 and just graduated college. My mom was her teacher in college and Anna is my role model. During college she traveled all over the world, learning languages and living in new villages and towns. She did a lot of writing.

Anna wants to be a teacher. She is still working on that. I do not think I could teach because with my luck, I would get a job teaching in a cheese-town.

The second part of this fictional memoir is the story written by the mother of Abagail. It is titled "Growing up at 56 or Nobody Pays Attention to Me". This mother laments her role as artist and single mother re-entering the world of dating. She observes her life in a critical, remorseful, new age manner. She is ready to start over yet remembers her marriage as full of mistakes and mistaken identities. There is increasing awareness that the mother develops as she sees the world from her daughter's perspective.

Cheese Town

Abagail calls our town, *Cheese Town*. It makes me

laugh. My son, Sam, never laughs. He hates being called

Cheese Boy in Cheese Town. Jake thinks we live on the edge

of civilization and Claire does not care as long as she gets

to the playground in town every weekend.

I think this community is rather typical for Vermont. I

have discovered that this state has an attitude. People can

be rude, opinionated and stubborn. Yet when the storms

hit, they are always there for each other. Several storms

last winter were rough for us. My neighbor, Louise, has a

farm down the road and she always checked on us. She is a

salty Vermonter. She expresses herself on any topic

presented and she refuses any social invitations.. She

watches and is present to her animals as well as to our town

And she can present a gentle, kinder side when needed.

I love Louise. She walks about our town with a certain stomp

about her. Folks nod her way or give that Vermont

"wave" of their hand. She never stops long enough to

chat. "Too much to do and never 'nough time," she

comments.

I think there could be some gossip that spreads quickly in this Cheese Town. Abagail warns me of it all the time. It distresses her and makes her crazy when she imagines that neighbors are talking about us. Since my boyfriend, Nate, moved in with us, Abagail is convinced that the town gossips about her mother.

"Why would that white-haired hippie want that redneck Vermonter anyways?"

"What do you suppose they are doin' in that yellow farmhouse, paintin and frolikin about?"

I assure Abagail that I do not care. **She should not care**. We are all fine and doing nothing wrong. It does not seem to help because she gives up only temporarily then she comes home with new stories and fears.

Racial Concerns

My daughter Claire is African American. She has beautiful dark skin, thick knotted hair and huge dark brown eyes. Her smile is the most beautiful smile I have ever seen.

In Ohio we lived among a racial mix near the university. It had advantages and I did think at one time that it could be a nice fit for Claire. But life happens and we are here in the whitest state in the US.

I am making peace with a lack of diversity in color here in

Vermont, yet I always hope it could change.

My yellow farmhouse near the dirt road stopped a few trucks after I moved in. Folks were not used to a young black child running about outside. Nate and I have conversations about these Vermonters' impressions. Some folks are nice enough with Claire but because she can react to things in strange and often unpredictable ways, many towners think she reacts that way because she is black. I think it is too, too bad that people cannot just look at my Claire for Claire and see her color in the pure white mix of this state. Claire tries to make friends in her own way.

Recently Claire's dr put her on a new medicine that seemed to make her bolder and more outspoken than she ever was. I received a call from my neighbor down the road. It was Addie who lives in a new trailer. She is a middle age woman who keeps to herself and who has lived in Cheese Town her whole life. Addie has never talked to me nor waved. But now Addie called me on a Saturday afternoon and was in a rage. It took a few minutes on the phone to understand that somehow Claire rode her bicycle to Addie's trailer, parked it in her newly planted garden and decided to walk right into Addie's kitchen.

My neighbor was mortified and wanted me "down there" immediately to retrieve my daughter from her house. Of

course, I ran out of my house without shoes and began

running down our dirt road to get

Claire. This was something she

NEVER did before and I tried to

explain it to Addie that I thought

it could be the new meds. Addie did not want to hear.

She told me it was "unacceptable for any child to jus' waltz

right into a person's home and I appreciate it if you tell her

that!!"

I never made it to Addie's trailer. Claire met me halfway,

totally happy yet puzzled when she saw my face. I began

crying. It was one of those moments when I believe I felt

like Abagail feels all the time.

I did not fit into this town.

I am trying to grow up at 56 and yet I feel so alone. No

one understands me and certainly NO ONE, except

sometimes me, understands my daughter. Maybe no one

understands either of my daughters.

Thoughts and feelings were flooding me as I escorted

Claire home.

She was scared, I know, because when I cry she knows I

am upset and in distress. Claire and I made some

lemonade and sat at our kitchen table and talked. I asked

WHY she would walk into someone's house.

Claire softly replied, "But I wanted to say hi. I knocked

three times on her door, Mommie, but Addie would not

come. I saw her in her kitchen but she would not come.

So, I just went in to say Hi."

I hugged my daughter.

I wondered why that friendliness is unacceptable in my

town? This beautiful little girl, unaware of her space most

of the time, is not going to hurt anyone by saying hello. Is

it because she is dark-skinned? What if Abagail,

my blond blue-eyed daughter, walked in to say HI?

Where I Fit

I am 56 years old. I work all the time and have a small

paycheck. I raise four children, one who is starting college

at 21, one who is finishing high school in a year and wants

to be a woodworker for life, another radical
young artist who is totally

pissed off at the world, and another child who
is black with some special needs

and no filters on life most of the time.

My boyfriend is an amazing carpenter, plays jazz, is sexy

and rebellious and intellectually a brilliant person. We

will never marry because I will never marry again after my

experience with Charles. I feel like I need to be alone.

Maybe I am destined to be alone forever.

I get irritated but I cannot express it because I think I will

be screamed at like Charles screamed at the kids and me.

Nate does not scream but he does walk out. He has

trouble with a monogamous relationships because he has insecurities he cannot face. He has trouble being around my children in such a small farmhouse. There are nights that homework is completed with everyone talking, asking questions and becoming annoyed with each other. The kitchen shrinks when we are all in there working. Now Jacob has his college work. I try to get Claire to bed early but she has homework, too.

We are a family. I know we love each other but we all have needs. Everyone wants to be heard and they want their needs met, mostly right away.

I do not think I am a great mother but I am still growing at the job.

I think I am a good lover but there is not enough time for that.

I could be a great painter but now my studio is in a back hallway.

Life goes on. I find I am deliriously happy most days, even the days I cannot find enough money for gas or I have a crazy painter's block.

There is a security in owning this life.

There is peace in knowing it could get better (even if it gets worse first).

There is joy in the little bits of happiness that crawl into my space once every so often.

There is a good feeling in lying next to a person at night

who just loves me for who I am, even if he does not stay

forever.

I am who I am and I take pride in whatever I become.

Even in Cheese Town.

The third passage in this memoir is written from the perspective of the oldest child, Jake, a 21 year old who is just starting college. *"21 Makes me Legal or How Many More Years Before I Retire?"* is the narrative that gives a perspective on how hard it is to find self at any age in any place. Jake describes self, family and his own identity issues in a family of non-conformists:

Never Fitting Into Life

I had a lot of trouble learning to read when I was young. I

think I remember dad helping me but then he would get

pissed and tell my mom that it was her job to teach me.

Mom helped and she would read to me a lot but I think I

also got distracted from the stories. I loved the kid stuff

like Power Rangers and Ninja Turtles and those

Gargoyles. I always made friends easy and everyone

seemed to like me. But I was not the best student.

My brother Sam is four years younger and he loved to

read. He loved doing homework, too, which really made

me wonder about him. He did art all the time and I loved

doing that, too, but Sam always seemed to do it perfect.

Sam and I made a lot of art with Mom. She had a huge

studio over the garage in our Ohio house. She would

take us in there with her and also teach other kids. I was

always her helper; in fact I think I helped more than I did

the projects.

Mom is an amazing art teacher. She loves whatever kids

create and she always talks about art---all the time! It

kinda made me bored because she would go on and on.

By the time my sister, Abagail, was born I knew

my mom and dad would divorce. It was going to happen

because my dad screamed all the time They argued about money,

my mom's job, and us kids…a lot. Dad hated spending money.

Mom did not talk about that except if it was something she

wanted to get for us. For example, I needed all new

hockey equipment when I was in sixth grade. Dad

refused and said I needed to wear my old skates.

Mom told him that they did not fit but he still insisted that

"we do not have the money, Catherine!" I tried to wear

my old skates but they really hurt my feet.

Mom cried. I saw her in the car one day crying and then

somehow she got the money later that day and I got my

skates. She told me to thank Megan who was her friend.

I do not know why my dad was the way he was. He made

my mom sad and I know that her last few months in Ohio

were hard. She cried so much. I was working a really

great job and I planned to move in with Nick, my friend. He

already had an apartment nearby. I told mom that I was

not going to Vermont and I think she cried again.

But I needed to figure out my crazy life.

I felt like I needed to grow up fast before 21.

These three characters all make transitions in their lives, and they move through these transitions with the pain and the self doubt that everyone feels when change is upon them. Yet they all embraced the fear, opened their hearts to the doubt and anxiety and migrated through the emotional mess that causes us all to go bankrupt of desire unless we open our awareness and our capacity to grow within the state of **migrating past the fear**.

Abagail's final passage reveals the enormous capacity she feels to open herself to her sister, Claire's daily struggles. Abagail has keen observations.

Our White Family

I no longer worry if Claire is mad at us because we are not black. Lately, I have been doing her hair for her (and for mom because she sucks at doing black hair!) Claire said to me, "I wish I had hair like you, Abagail." I stopped and looked at my sister. I laughed. She started to get mad but I said, "Wait, Claire! I hate my hair!! I would LOVE to have hair like YOU, Claire. Yours feels so soft and you can have dreads someday like my friend, June."

Then I remembered what it was like when I went to June's house. There was June and her mom and June's Aunt Lela was visiting with her three sons. We all had dinner together and I remember what it felt like to sit at their big table. Everyone was dark. June's mom and Aunt Lela had Jamaican accents. Their hair was wild and their bodies beautiful and stately. I was skinny and pale. I remember feeling like I was the outsider in that picture. This was a family of beautiful black people and I did not fit in.

That is how Claire must feel every day. Not only must she see so much white at our dinner table but she goes to that school and sees only WHITE faces! At least June gets to go home and see something familiar.

I think when I realized that then my sister's upsets made sense to me.

I just do not know what to do about it. But it does become another reason for my mom to move out of Cheese-Town.

Nature was the place of victory. In the natural environment, everything had its place including humans. In that environment everything was likely to be shaped by the reality of mystery. There dominant culture (the system of white supremacist capitalist patriarchy) could not wield absolute power. For in that world, nature was more powerful. Nothing and no one could completely control nature. In childhood I experienced a connection between an unspoiled natural world and the human desire for freedom.

bell hooks

Belonging: Understanding a Culture of Place

Chapter Eleven — Returning to Place

Born in rural Kentucky, bell hooks decided to return to the hills of Kentucky as an adult. Although she now lives in the town of Berea where she teaches at Berea College, she travels back in time and in place to the hills where her foundation for her scholarship lay.

hooks grew up in an average home with memories that are keenly all-American poor black as she describes the natural setting of her childhood. But inside that life of a black American girl were also the embedded elements of the poor whites living in those hills. Living alongside those poor whites, hooks knew she should stay away from them, yet she did not know the racial/cultural identity that was forming inside her.

hooks left to go to Stanford, and over many years of living in cities and experiencing the identity of the black woman in urban areas, hooks sensed and experienced firsthand the racial slurs and differences. She learned her place in those cities, and she did not like it.

hooks realized that there must be another place of belonging for her, and returned to Kentucky.

I found this journey so intense as I read about hook's lifelong achievements and I felt pride in her accomplishments. Yet buried so deep within was her sorrow at having lost and never quite found her true identity. She needed, longed to return to a place where she felt safety and comfort. This reveals the power of place intersecting with the lives embedded within a community. It carries with it torn emotions such as the anguish hooks felt at watching the tops of the mountains being sliced off as coal was mined from beneath the surfaces.

hooks discusses how the folk in the hills live with less. Their lives rests on strong values and ownership comes from knowing they once had less. The poverty experienced in that place was diminished by the true wealth they felt inside, wealth resulting from their independence and a sense of belonging.

That is what drew hooks back to her life in Kentucky. The memories of freedom and establishing herself in a climate of simple values and honest hard work makes her reflect deeply on her experiences in and out of that one true home. She writes, "This rethinking often includes a return to spiritual values which often acts to reconnect folk with nature." (31)

Wendell Berry writes about similar feelings of deep connection to his place of home inhis Kentucky in the following poem:

Sowing the seed,

my hand is one with the earth.

Wanting the seed to grow,

my mind is one with the light.

Hoeing the crop,

my hands are one with the rain.

Having cared for the plants,

my mind is one with the air.

Hungry and trusting,

my mind is one with the earth.

Eating the fruit,

my body is one with the earth.

—Wendell Berry, from *The Mad Farmer Poems*

As an adult I finally saw that my father's hard work and simple values were his gift. He danced when he felt happy. He laughed often and loud. His eyes were creased with a hundred laugh lines and his skin roughened from the once hard winters we had in our town. My dad slept little because he also delivered the morning paper from 2 am - 5 or so. His sleep was napping an hour here or there. He never complained. He never thought my mom should work because he knew she couldn't because of her anxiety and he wanted someone there for me while I was growing up.

Yet little did he know, that he was the one there for me. He was my role model throughout life. And once I reached about 40 I realized that he was right, I am called to be a teacher because it is the best thing I do. That simple reality was my fate and one I then embraced because his life became my creed. I wrote in 2002 a sign that hung in my studio for very long:

Even though I traveled in and out of many avenues in life and all over the world, I realized what my father had been telling me for years: the simple things in my life bring us the greatest happiness.

I did return as hooks did. I returned to Cincinnati and to that sense of self that my father left me when he died in my arms in 1997.

Chapter Twelve — Settling In

I keep Christmas lights twinkling in my house all year. I add more during December, but in July they can be seen in my kitchen. I find it comforting to be reminded of that peace-filled presence even as the August heat rolls into Vermont.

There is a tradition in this state of leaving outside Christmas lights up through June. At that time most people take them down or at least decide not to turn them on at night anymore. Occasionally I have seen a farmhouse on a rural route with a Christmas tree or Santa Claus on the porch lit up in June or July. I love those moments, passing a house, which tells me Christmas is a year round event.

That predictability of virtue and kindness makes me believe in the power of this place.I adjust and feel a "settling in" as I move about my village, stop and talk to others at the General Store, linger at the post office and deliberate over the postings on the bulletin board in town. This place is home.

There is strength in spirit and character in knowing I am accepted. I am still a flatlander, always will be, but the locals know my journey here is one out of respect and love for their customs and lore. I am not here to change them or their landscape but instead to try to listen and hear their stories. In my process of settling in, maybe I can also give back and make the effort to enrich the soil and spirit of a community.

I am a nonconformist. I am not sure anyone here this state really conforms. Vermont is filled with singular individuals. While they express themselves in different voices, the melody sounds the same.

A path of nonconformity is what my dad taught me as I grew up in his presence. He knew how to bend the rules but to seek the perfect balance, always with humanity, goodness and equality in mind.

I have a bumper sticker (one of many) that reads "Why Be Normal." It fits me. It fits most people I meet in my travels through this state. Standards are held high yet, those same standards are here to be questioned, broken and then fixed. These standards envelop a community that rests ideals on how well crops produce, the number of days for sugar season and when the last cord of wood gets split before winter snow. Answer really is: these decisions rest not in the hands of Vermonters but in the lack of predictability of Mother Nature and destiny.

Why mess with destiny?

Destiny gives us a structure for determining our next step.

Blessing!

Artwork 22: *Sky without Limits*, **Acrylics, 2009**

Virtue can be found in the unexpected, those nonconformists that settle into the cracks of society but make marks that reach beyond their farthest reach. Those individuals make the difference for hope in our world.

My father believed in the power of reaching one mind at a time. As he grew older his love for students with special needs and challenges grew. He reached out in particular to the students with Down's Syndrome, and one boy named Paul caught my dad's soul.

Pop would do anything for Paul. He took him on special field trips, would visit his family to talk and eat a meal, and would later call to check on Paul after Paul graduated from the eighth grade. Eventually, at age 20, Paul passed away, and I recall the heartbreak my dad felt as he had to let go of that connection in his life. I asked my dad why he loved working with students with these challenges. He said in his simple yet profound manner, "They hold no pretense; they offer more of themselves to others in open and honest ways."

What if we could find ways within our communities to discourage pretentiousness? Why can't we let the unusual, the not-so-normal, the creative spirits surround us? Must we look outside ourselves and criticize to give validation to the experimentation of our lives?

I think about these openings in my heart and I realize that as an artist and a teacher, I seek out the underdog. I find it easier to be compassionate in my soul for the person who struggles than for the person who has all that she needs and never has seen a struggle.

That could be why I feel at home in Vermont.

Throughout my work here, I have explored the passages of lives that experience pain and struggle and hard work daily. Most of these people still smile or nod hello and share stories, offer condolences, and always lend a hand in times of despair.

As my life took a turn for the worse in December 2009 and I drove the wintry roads to Burlington to be with John in the hospital, I knew my children would be safe back in Cabot. Neighbors came by bringing food; their teachers called or checked in at my house as the school secretary could be reached at any time to help me figure out transportation or child needs. I never felt alone.

My friends back in the Northeast Kingdom drove across the state to Burlington to be with me. My Wiccan friends brought herbs and chocolate and their Tarot cards and they carefully made my bed on the floor of the hospital waiting room. These women sat with me nearly through the night and gave me a reason to smile again.

I find support in Vermont.

It is all about care, concern and community. It is that feeling of growing old with your neighbors beside you, losing some battles while knowing that many were won along the way.

It is about comfort.

One Sunday in January 2010 I needed to drive 90 minutes away to my partner's funeral service. I had to be away from my house with my children for this painful, unpleasant event. It was blustery cold and our wood furnace was acting strange pumping out smoke through our small house. I had no time to understand this issue. My partner had always helped me with these things. I relied on him too much. My life was in turmoil from his loss and my children were grieving. So, all I knew to do was to call my neighbors, Mark and Jen.

> Lying amidst wildflowers
>
> Dreaming beneath tall trees
>
> Sunlight drifts to moonlight
>
> Listening for your footsteps
>
> The brush of your dress
>
> Rustling sleeping buds
>
> Your warm breath
>
> Bringing the sun
>
> —John Young *Lying Amidst Wildflowers*, 2009

I asked Mark to try to check in on my house sometime that day. Of course, he did because that is what my neighbors did. Despite their busy lives and their own worries, there was always time for one more thing.

That thing almost burned down my house. Thankfully, it was still standing when we returned that night. But it was because Mark, after putting out the wood furnace fire and thinking all was okay, stopped at the front door. He said he stopped and felt a presence, making him question, "Is this house really okay?"

Mark turned back, picked up the phone and called the local fire department. They came with sirens and three trucks up my steep hill. In a deliberate and swift manner, they put out a chimney fire and cleaned up the mess.

But that was not all. Mark also gave a call to the town expert on furnace systems. Fred, a local who lived in Vermont, in this town, his whole life, did not hesitate to come up the hill on a Sunday afternoon and work on my furnace.

I am not sure if Fred ever sent me a bill.

There are few places in America, maybe in the world, where community feels like it feels in Vermont.

In the fictional narrative, the mother, Catherine, discusses these issues of acceptance and settlement in her family and her community life:

Making and Keeping

> There was a point in this past year when I thought I needed
>
> counseling for Abagail. She was never happy,
>
> always whining, always irritable. I spoke to my friends at
>
> my college and they assured me, "She is an adolescent girl,
>
> 14, and it is her job to make you irritable."
>
> So, I made peace with my daughter's ways. She could be
>
> swinging along in great spirits then boom; it was like a
>
> sudden thunderstorm hit over the mountains, out of
>
> nowhere came the turbulence. Now, with my recent
>
> advice, I was in control. I faced the storm, let the waves of
>
> thunder crash upon me, then let the storm pass by. I stood
>
> tall like a ship on the sea.
>
> I think my daughter's ways have made me stronger. All of

my children teach me to be strong, if not to fight for me but

to fight for them. With courage I can face opinionated

neighbors, teenagers with their own agendas, and old cats

that find refuge in my barn. I can accept and be more

tolerant. I can embrace the storms and greet them with a

mother's love.

I think the best idea for me as I settle into this new life, is to

keep perspective on who I am. I cannot conform. I could

not conform to Charles's expectations and it made me bitter

and restless. With my unhappiness came Charles torment.

With his torment came our unhappiness as a family.

It all collided, and while I never wanted to face a divorce,

in my heart I knew it was inevitable.

The glory of this moment now is returning to the values I

always held inside me: nonconformity, values of honest

hard work, creative freedom, and the preservation of a life

of spontaneous joy.

Once in a glimmer I see that joy in my teenage daughter's

face. If she catches me witnessing it, it surely disappears in

an instant. I hold on tight to making my life real and

keeping myself true to this process.

Catherine brings the essence of place into her life, her art and her family. All this sounds quite familiar to me, and then I remind myself that I did write fiction. Or did I? Place defines us in ways we never truly expect.

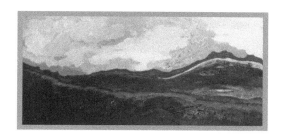

Artwork 23: *Untitled*, Oils, 2008

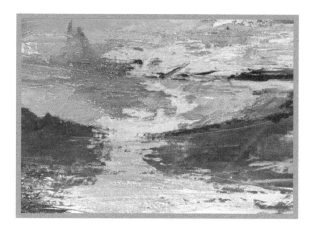

Artwork 24: *Newness*, Oils and Acrylics, 2008

Winter was a cloak and it held me

The cold protected me from looking within

Now comes a melt

The water flows rapidly off my mountain

I walk just to hear its breath

There is no cloak

The path to spring is revealing itself

I am revealed in my work

I cannot hide behind the layers any longer

The paint tells my story

I melt into my mountain

Kumari Patricia 2008

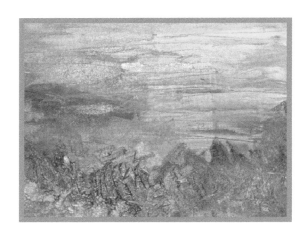

Artwork 25: *Spring Green*. Oils, 2008

Chapter Thirteen — The Spring Melt

There is nothing to compare to mud season in Vermont (except perhaps Mud Season in Maine!). Cars have been known to disappear into the mess of the melt. There are roads that can't be driven. Tires of any sort can be useless and even walking in your mucks can be dangerous.

The most important thing about mud is to appreciate it for what it leads to. Thaw. And sugaring. Rain. Summer. Gardens.

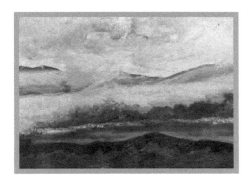

Artwork 26: *Clash of Clouds*, **Oils, 2007**

Sugar season smells the best as you are driving through the mud and slipping your way into ditches and ruts. It reminds you of the gifts that the freezing and thawing of weather can bring. It is not about the headache of getting through the mud and those washboard ruts in the road, but about the time you take to stop and smell the sugar houses. It is a clear reminder of the benefits to Vermont and the indifference you are capable of feeling toward knee high mud over the edge of your boots.

However, it is also a good idea to know how to get out of the mud once you are in it. During my first year in Vermont, I rented a place in the mountains. As the melted snow ran down the mountainside, I could tell that mud season might pose a real problem. However, my landlady told to me in all seriousness, "This place is a good rental because you know ya' got two ways to get out during mud season."

Now, as a seasoned muddied Vermonter, I can listen to those statements, nod my head and mutter the Vermont phrase, "Jeezum crow." That phrase, a traditional Vermont substitute for a sacrilegious curse, can express the sheer frustration of any weatherrelated obstacle at any moment.

Last March I got stuck in the mud.

Archie Portigue was there, thin

from the cancer that would kill him,

with his yellow pick-up, its sides

akimbo from many loads. Archie

pushed as I rocked the car; the clutch

smelled hot; then with finesse

he jumped on the fender…Saved,

I saw his small body in the rearview window

get smaller as he waved.

—Jane Kenyon, from *The Town Dump* poem

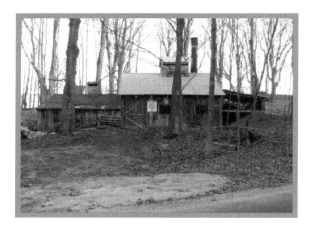

Sugar House in Kirby, **Spring 2008**

After the rains, the melt comes, and slowly the joy of spring returns to the earth.. This is the time for planting, and Vermonters embrace the study of the earth, ripened for the seeds and tilling. There is a rejoicing in the gardens. There is a meditation to the daily movement of studying, bending, touching and turning the dark soil over in our hands. It symbolizes the birthing of a season that everyone awaits with eagerness and sensitivity.

Entangled Trees, **Photograph, 2007**

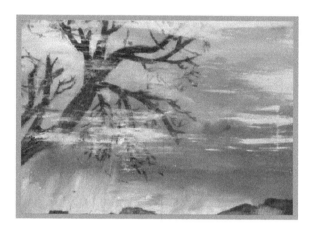

Artwork 27: *Trees in Winter Storm*, **Acrylics, 2008**

Chapter Fourteen — Planters and Wallers

As spring approaches, the smell of the earth moves through Vermont. Many folks are outside on the days when it does not rain. They are moving about and planting gardens, cleaning the yard from winter debris, fixing broken things, cutting trees back, trimming edges and also building stone walls. I learned a new word for those people who carry the heavy stones and stack and place and move about slowly: they are wallers.

I love that name.

I constructed an essay, "How Place Fits", into my creative practice. It discusses some of what will follow about my house but also about stones and rocks and the relationship of the land to the water and stone elements. It is all demonstrably affected by my sense of earth and the growth that emerges from season to season. I see this birthing process as I walk my land.

The rocks that lay their heads upon the land in Vermont are ones that form the sensuous flowing walls. Hard work built those walls, some of which are still built today. I enjoy traveling the backwoods during the early month or two of spring and seeing these walls emerge after the ice and snow melts off their faces.

I see water in a way that symbolizes our lives. The water is there with us. We appreciate it every season and watch it change its form. Yet, it is a bountiful pleasure to step back and observe the movement and listen to its voice outside of ourselves. The water speaks softly within us always, although at times it can become a mere whisper.

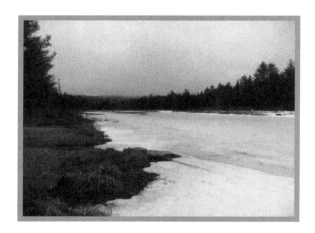

The water brings us to a resting point in its flow. It nourishes our spirit and cleanses our souls as we wait for the sun to illuminate our reflections upon its glassy surface.

The stones tell the stories. If you listen closely, you will hear the trials and tribulations of the way those stones fell or were placed by hand in an honorable design that gives tribute to Mother Earth. There is a legacy of stones, and they all belong to one big family. They are related and they are proud of where they are placed.

Stones have feelings that are embedded in the earth's core of time. They speak to each other as they sit and study their place.

The stones form lines in the earth that weave in many directions, always leading back to home.

It is a magical flow as I see the water bubbling throughout the landscape. There is a comfort to the thought that spring is nearly with us and the winter is a dream. The sense of a place over time is created by the stone settings as they hug each other and touch the dirt. They create a design in their smiles and their frowns.

Lonely stillness---

A single cicada's cry

Sinking into stone

—Matshuo Basho *Narrow Road to the Interior*

My Cabot land is rolling and sensual. I love to walk it. It is not exhausting. Instead I feel revived when I move about the gentle inclines and soft slopes. I think about Myra.

Myra Houston was the woman who died in my house. She was the last Houston member to live here. She died in August of 2006, and I purchased her house from her eldest child, David, on July 3, 2008. This old farmhouse has Myra's presence. We talk about "the old woman." My daughter, Rachel tells me about conversations she has with "the old lady."

While this witchery could frighten some folks, it does not frighten my family or me. We seem to love Myra. She was 70 years old when she died, the same age as my own mother when she died. Myra's husband predeceased her. Both had wonderful reputations in my town of Cabot.

A good friend of mine, a well-known Vermont Wiccan, did a "house reading" in the fall of 2008. It was my first house reading and house cleansing, but it was not the first one for my friend and partner, John. Another friend, Jean, attended as support because she is Wiccan and is very familiar with the process. Both John and Jean could *feel* things moving about and doors opening and slamming. I was not as intuitive, but I believed in what the reader told me. She knew all about Myra.

The reader knew that Myra loved her garden. She told me where Myra placed her garden over the years of raising her family. That is the spot where we are re-building it now. Part of it will be Rachel's garden. The reader spoke to Myra about Rachel. I guess Myra really loves my daughter a lot. She wants to protect Rachel and see that she is safe. Me, too.

Artwork 28: *Moving to Fall*, **Oils, 2007**

Chapter Fifteen — Re-Building the Past

Or

How to Go Broke by Buying a House that's Falling Down

There is a beauty to looking forward from the past.

Spring unfolds, as do the projects around house and home. For me this is clearly evident as I look to re-building the past in my present. This is through the reconstruction in my house.

I am trying to uncover the stories behind my house and as I add more space (needed with six people and five cats and an old dog). I am looking to both the setting of this hill in Cabot and to the past generations of farmers who worked this land and admired the beauty of this old house. It is about land, relationships and the composition that can be created as the elements of life and land gets crossed. As I began to uncover the history in my house, I found a relationship building within me with both Place and with Family.

It is also about building a story. We are another family who can connect experience with land and the value of that relationship. I saw this stated so well by Baron Wormser in his book *The Road Washes Out in Spring*. This book took the journey of Wormser and his wife as they built their home on the landscape inside Maine, in a place that few traveled and where morals and values rested in the relationships built in a small rural community. Wormser relates the same perceptions I often have in my community within Cabot. As he introduces his ideology about building a house, he explains the virtues of authenticity and sustainability,

> The buildings stood on the ground but not of the ground.
>
> We wanted our experience to savor something lengthier
>
> and deeper. We wanted to taste the water that came from
>
> where we lived rather than the reservoir or holding tank

many miles away. We wanted our food to be food we

grew, and our warmth to come from trees we cut down.

We didn't want to possess the earth, we wanted to be of

the earth--a different concern based on a different

economy. (26)

Wormser continues by discussing the realities of his simple lifestyle in the back woods of Maine. He sees that engagement in the subtleties and simplicities of existence as compared to poetry and the bend towards harmony. The harmonic relationship comes from the words, the beat, and the syllables that frame the reference of images and story.

I can see that same harmony evident in paintings and the interpretation of visual images. The composition needs to fit together, whether in the words, the shapes, or the passion for an authentic life created within the landscape.

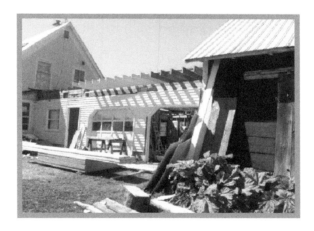

House Project, **Summer 2009**

Once 200 Acres

At one time my farmhouse sat on 200 acres of Vermont soil. It was a working dairy farm with Jersey cows, and the Houstons also produced maple syrup and grew potatoes. The farm survived two full generations in the Houston family. My house was the main farmhouse, albeit a small main one now, due to a fire that took down part of the house and barn.

The Houston family owned the house. Donovan Harvey Houston worked as a farm hand for the grandfather of Francelia Goddard, a New York resident. Francelia used it as her retreat in summers for many years since she was one year old.

Donovan was born in Walden, Vermont and he went to school in Cabot. He attendedthe Vermont Technical College and graduated in 1929. Donovan worked as a milk tester for seven years, staying overnight on each farm doing his testing and book work then moving onto the next farm. In 1931 Donovan married Pearl, a teacher in Derby, Vermont. By 1935 they had bought the farm in Cabot. Donovan and Pearl had four children: David, Sr., Cedric, Wayne, and Ilene. They all grew up in the house that I have.

There were several fires here and one major one took down most of the house and the entire barn that was attached in the 1940s or 50s. The house was re-built on the existing foundation with new barn and outbuildings.

On May 17, 1958 David Sr. married Myra Anderson. It was after WW II and David had attended the Vermont Agriculture and Technical College. They built the small ranch house not far from what is now my house. David worked the farm alongside his father doing the milking and sugaring. They shipped the milk to Cabot Creamery.

Myra was from Meriden, Connecticut. She was not used to farming and Vermont was a big change in her lifestyle, but she settled in and took care of the house. She was "the quintessential homemaker," according to her daughter-in-law, Emily Houston, who is married to David, Jr.

Myra cooked and baked and took care of the children, David Jr,Dawn, and Eric. Eric, the youngest came along to them much later. Myra did love to garden and they put in the garden in the same spot that John and I have selected.

When Myra and David's two oldest children were in their teens they switched houses with Donovan and Pearl. Myra then moved into my yellow house.

Francelia Wilhelmina Sheldon-Chittenden Goddard

Francelia Goddard loved this farmhouse. She said it was the happiest days of her life to return each summer to the hill in Cabot, Vermont to her grandfather's farm. Her grandfather was George Francis Harvey, born on August 22, 1843 and died on April 26, 1928. He was married to Francelia Katherine Kimball Harvey. They owned my farmhouse before the Houstons. Francelia, their granddaughter, spent her summers in Cabot.

Francelia was born on May 11, 1907. Most recently, she lived in Santa Ana, California and she wrote many passages about my house, and her summers in Vermont and about her grandfather:

My mother's father was what would be known today as 'a character'. He was born a farm boy, the sixteenth and last child in his father's family. He lived to be well over eighty and founded two good-sized businesses which are still going strong 25 years after his death.

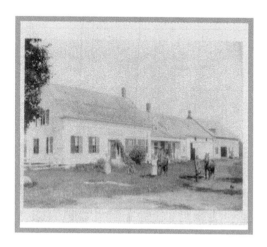

My House in the early 1900's

Francelia Goddard wrote about this farm:

> At the extreme back of the Edge Hill property, which went down behind the barn and hen houses, through birch woods, was a small two-story cottage. It was well insulated for year-round living. I believe it was rented out. I remember one 'Negro' family living there when I was quite young and going down there, without the knowledge of my folks, and having a lot of fun playing with the children.
>
> Eventually he gave the cottage and one acre of land to my

mother and after his death, she gave it to me. I had several house parties there and Allen and I spent our week's honeymoon there.

I should tell you that I love to brag about living in 40 degrees below zero weather. They told me it got that cold the winter of 1907-08. My mother and I stayed at the Farm with Orson Kimball that winter because my own father, William Sheldon, was dying. He died in March of 1908 in the Hardwick Hospital. When I was 3 and a half my mother married George Herbert Chittenden. Their wedding was in the parlor of THE FARM.

It was common for weddings to take place in the parlor of my original house. Adena, Francelia Goddard's mother, was born there. Around 1905-07 the house was remodeled. George F Harvey "raised the roof" and increased the number of bedrooms to eleven.

Between 1928 when George Francis Harvey died, and 1935, when Donovan Houston bought this farm, there was another owner, Joseph Couture. On November 5, 1934 there was a massive fire in my house. The Couture Family was out except for one daughter. She ran to sound the alarm. Neighbors saved most of the contents of the house and three horses and two bull. Forty head of cattle perished in the barn. Two months before this big fire, Mr. Couture had died in a Barre hospital. His widow and children had been living at the house.

The *Barre Daily Times* stated the following about my house,

"This house was one of the best farm houses in town, containing 20 rooms and being well-furnished. In the days when George F. Harvey of the National Drug Company of Philadelphia occupied the place as a summer home, the house was the scene of much entertainment with many visitors present."

From Ashes to Home

My house experienced two major fires in the 1930s and the 1950s. As I began to uncover the history in my house I found a relationship building within me, both with Place and with Family.

I feel connected to those other families in ways that only people who live under the same roof can feel. At times I sense their presence. I feel nurtured by the stories I hear about Myra Houston and her compassion and love of her community. I sense the great love and respect of Francelia as she anticipated each of her summers in my house in Cabot. I sense her joy and her days as a child running through these fields.

Francelia died on September 9, 2009. She was 102 years old. Her grandfather, George Harvey, made my house known as the Harvey Farm. He "raised the roof" and built a much larger, prestigious house.

I am not looking for prestige or glory under this roof, but it would be nice to add the space and bring the fuller essence of this house into perspective. So I am planning my own project to "raise the roof" of my Cabot place.

My feelings run deep for these stories of lives within the crevices of my house. I respect their past and I hope to re-create the beauty that was seen so warmly by many. It will be a long journey of rebuilding and re-evaluating and re-connecting.

One night in the spring of 2009, I had my first sleepless night of tears and panic. I cannot recall ever experiencing that except for when my father was dying and I cared for him. I realized as I sat up wet from the sobbing, that I was afraid. This was the first time in my life that I had been alone. For two years I had been paying bills and buying the food and paying rent or mortgage. Some months I didn't know how the checkbook balances. Some months I'd be a week late with the mortgage check. There were times I would tell the kids that they must wait for certain things, even things they might need. I would buy the essentials. I was grateful for all the secondhand furniture that people gave me when I settled into this house. I knew the house was too small, the plumbing leaked, the flooring needed to be removed, the ceiling was falling down in the mudroom and porch, but I looked around and said, "Ah, it's yellow. I always wanted a yellow farmhouse." Molly looked at me and said, "Yeah, Mom, you always wanted a yellow farmhouse."

There is a sense of freedom to this nonsense in life. It is my nonsense. I knew my former life was ugly. I had to look up from my tinted glasses and admit the truth. Still I doubted my own choices.

I had to move on the pure courage and will to make it happen.

Chapter Sixteen — That Other Vermont

Building on Route 215, **Cabot, Vermont, 2009**

People imagine and defend the beauty within Vermont. While there are pockets of wealth that exist in the terrain, much brought into the state from flatlanders who see opportunities to exploit the natural beauty that exists here, there also exists the spaces in-between. There are many sites that are collapsing from decay and neglect. There are homes that can barely withstand the winters. The restoration processes for these dwellings involve hard work and time and money. I see Vermonters who work hard on propping and stabilizing old structures, but it is a long process and it needs to be coordinated with weather, including rain in summer.

I see these obstacles within the lives of Vermonters as a part of the struggles that face the inhabitants daily. Within the Northeast Kingdom the rate of alcoholism, joblessness, incest and suicides is very high. There is the sense of rural isolation that some inhabitants love, yet others feel can be debilitating. In particular, the winter months can cause distress and depression among many who cannot get around freely.

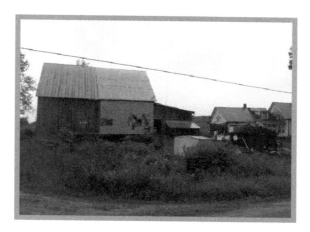

The natural beauty of the mountains is juxtaposed with the challenges of work, maintaining vehicles, and caring for a house that is well-insulated and warm. Add to that an inadequate network of supports, that should be in place to address such problems such as incest, drug and alcohol abuse, and mental illnesses.

Downtown Hardwick, Vermont

Social problems appear worse in communities with harsh winters and where there are fewer inhabitants, roads are dangerous, drivers reckless, and the community resources are scarce. Expectations for change are low because the patterns seem predictable. Solutions for domestic violence are still investigated because that pattern is acceptable in families over time. Families continue their struggle yet those crimes and hardships are expected through generations of pain and disturbing relationships.

Towns can fall upon the hard economic conditions and that can present decay and destruction. The buildings are symbols of a community left to ruin when the resources dry up. Solutions involve the participation and commitment of each member, but sometimes those individuals struggle on their own. Seeing a larger picture

of hope and futures of re-building dreams is not always possible, if the property tax bill is higher each year and the wood is not in place by the fall. Hope and determination can become compromised.

Yet in the pockets of decay there sits the beauty of the natural landscape. They sit, holding hands and holding hope, for a future to be open to change.

Where do we begin to see the beauty?

When can spirit conquer elements of distress?

Can beauty be found in the abandoned landscape?

Sorrowful Eyes

Skies that form boundaries

surrounding the sorrow

consuming the endless mornings

when daybreak begins the story again

The mountains whisper the truth

Yet no one listens except the victims

of struggle within poverty and abuses and jobs lost

Skies open souls

they hold the minds of mountains

and the fear of future mountains

No one is willing to look into

the eyes of a storm

—Kumari Patricia, 2009

Chapter Seventeen — Rising Above the Mountains

When I look into the eyes of the moon, I see the glimmer of light that crease upon my path home. The light takes me up my hill, Houston Hill, a hill that has been driven by many, a hill that challenges me in winter, a hill that takes me to the yellow farmhouse with five children, too many cats, and a very old dog. My Place is a place about which John Young once said, "Only a flatlander would buy a house up here." My Place is one where I rest. It is my place of creative growth and my refuge from all storms.

> Then I was alone. The volunteer caterers had cleaned up
>
> and put things away. I ate leftovers. Jane reminded me to
>
> take my insulin. Suddenly fatigue came over me and I
>
> knew I had to go to bed; I would sleep tonight. But first I
>
> drove back to the graveyard in the moonlight and said
>
> good-bye to the fresh dirt over Jane in her Vermont
>
> hardwood box, wearing her white salwar kameez. (14)

> —Donald Hall's *The Best Day, The Worst Day: Life With Jane Kenyon*

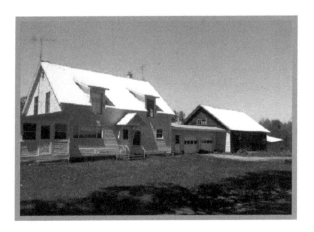

My Place transitions with the seasons and with my life circumstances.

My life as an artist transitions with seasons and time and all of life's circumstances.

On the 5th of January 2010, my dear soul mate, companion, yoga partner and closest friend, John Young died. On the 10th of December, John entered the hospital as he often did during his 54 years of illnesses, with the joyful spirit of a survivor, a person who, as his sister-in-law said, "cheated death more than once." I left the house with him at 5 a.m. with a dreadful feeling in the pit of my stomach, but John would not cease to laugh and wink with his cheerful spirit and love. I paced the hospital lobby, waiting for him to return to recovery. I drank stale coffee and fretted over the winter storm approaching. John accepted fate, embraced his destiny, and held my hand in the month that followed.

I journeyed to be with John nearly every day during that month, when he moved from a hospital room into the Intensive Care Unit. My children spent Christmas morning with the man they considered their true father figure and their mother's best friend. Molly hung Christmas lights over John's bed in Intensive Care. Ben cried for three days but felt consoled once he could join a neighbor friend and build a box for John's ashes. My son Chris wrote essays about John and the little time they had together. Rachel questioned fate and why it was inevitable that she lost another important person in her life as she did when her birthmother died. Erik would come to me as I arrived home late in the dark deep winter snow and he would simply hug me and tell me how much he missed John.

Such was grief and such was our life in Vermont.

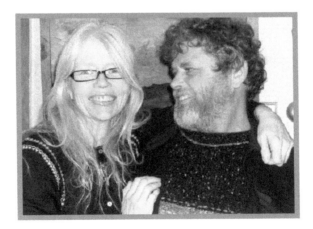

John and Patty, Winter 2008

My 14-year-old daughter Molly, a future writer for sure, wrote an essay about John in the fall before he passed from us.

John is my mom's boyfriend. I would consider him another dad. If it weren't for John my family probably wouldn't be doing so great now. When he first started living with us I didn't know what to think. I guess I was scared that he might not be so nice. I was surprised at how fast it took my mom to find someone else. Later I realized that my mom would never like someone as much as she does if he wasn't so nice. So I got to know him a little and he turned out much different than I thought.

He helps us with everything: the cooking (he is an amazing cook), fixing every problem in our new house (which was a lot). Building a new addition to our house plus cleaning anything in the house that my mom wants. Overall he taught me and everyone else a new way of life in Vermont. He also taught my brothers and I how to fish, hunt, and go camping. Camping was the most fun times with John because he teaches you everything you need to know to stay alive in the wilderness without shelter. He showed us that living in Vermont is not as boring as we thought it would be. There are things you can do to amuse yourself all over. You just have to know how to do them right. *Life Lesson*: Don't judge anyone before you get to know them.

I find that through my creative work here in this place known as Vermont, grief comes as a natural occurrence, as natural as greeting and saying goodbye to seasons, to livelihoods, to old friends. But do people actually go away or are they simply manifested in a different way?

John was the essence of my work here. He embodied the spirit of the Abeknakis, the spoil of the land, the bends in the mountain roads. John was an optimist, a Taoist, a follower of no one but a leader to many. He loved my paintings but did not claim to understand *art*.

John waited for me in his life. He told me that often. He had had many relationships, some decent and others perfectly horrible. I think I knew about most of the women. I was not afraid because I knew that our love was the special one he had waited for.

I had waited, too.

I had waited through my life in Ohio, my year in Kirby, Vermont and I had waited to realize the importance of a relationship as it is embedded in Place and Family. For that wisdom and for much more, I thank John Young for entering my world and for caring enough about me to always show respect in his language, his attitude and his smile.

My favorite part of Donald Hall's book about his wife Jane Kenyon, is the description of "The Third Thing." That third thing is what is there between two people even as they love each other. It is that thing that gets shared. It can be poetry, children, a favorite pastime. It is more than the lovemaking; it seems to transcend the physical act and bring the couple to the essence of what they see as important to and for each other.

Within Hall's book I saw my relationship with John. I saw the beauty that love holds for two people and the way it can add clarity to purpose, even at the time of death. Love does move life forward. Life never waits as patiently as love. We who embody life to its fullest must imitate the stillness that we all desire and seldom are given.

Zazen is that still point in zen meditation. As I seek to find that stillness in my day, as I paint, as I study the mountains that climb and kiss the clouds above, I will be thankful for the manifestation of my life to its fullest in this Place where beauty is seen in the smiles of the land.

It is with honor and gratitude that I look within, beyond and through these mountains. What awaits me will always be a surprise.

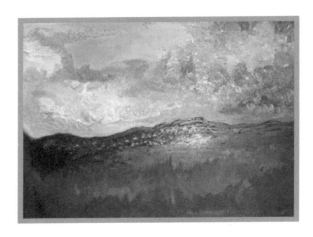

Artwork 29: *November Sky,* **Oils and Acrylics, 2009**

Hope

There is nothing that should make us believe in despair

Nothing

Hope

The mountains bring the new day that whispers the intent for a new beginning

Hope

My heart stays cracked and slightly bruised from the past

But nothing reminds me more of my future than my present

Nothing

Hope

The nothingness that once graced my images is no longer my retreat

I feel the start of this day as the sun creases the mountaintops

Hope

The children laugh

Hope

The radio speaks

Hope

The ritual of my life allows heaviness to lift for a moment

A new friend appears

Hope

—Kumari Patricia, 2009

Conclusion

Wendell Berry saw the agrarian lifestyle as his choice when he returned to Kentucky, his place of birth. In *Imagination in Place*, he states, "If you understand what you do as a farmer will be measured inescapably by its effect on the place, and of course on the place's neighborhood of humans and other creatures, then if you are also a writer, you will have to wonder too what will be the effect of your writing on that place." (14)

As an artist, I, too, feel that sense of responsibility as I pursue my work surrounded by place and community. Do I concentrate on just how my work is perceived or only imagine the paintings from my own, self-centered perspective?

Each day I continue to see wonderment in the mountain hamlets and low valleys. I respect the Vermont farmer and hold affection for the sustainability of the newcomers and the frugality of the old timers. Vermont tradition lives on in many minds and in families as the outside world continues to observe, scrutinize and pass judgment.

I do not hold harsh opinions other than what my vision tells me is the imagination of self manifested through this landscape. I am seeing my reflection daily as I paint. And I see my work as bell hooks put it from a Negro Spiritual, "I wouldn't take nothin' for my journey now."

Table of Artwork

Place-Based Artistic
Practice Bibliography

Albers, Jan, *Hands On The Land: A History of the Vermont Landscape.* London, England: The MIT Press, 2000

Armbrecht, Ann, *Thin Places.* New York: Columbia University Press, 2007

Bachelard, Gaston, *The Poetics of Space.* Boston, Massachusetts: Beacon Press, 1958

Baldino, Megan and Matt Hage, *Two in a Red Canoe.* Port. 1nd, Oregon: Graphic Arts Books, 2005

Berry, Wendell, *Art of the Commonplace.* Berkeley: Counterpoint, 2009

Berry, Wendell, *Mad Farmer Poems.* Berkeley: Counterpoint, 2010

Berry, Wendell, *Imagination as Place.* Berkeley: Counterpoint, 2010

Berry, Wendell, *Leavings: Poems.* Berkeley: Counterpoint, 2009

Boulet, Roger. *The Canadian Earth: Landscape Paintings by the Group of Seven.* Canada: Prentiss-Hall, 1982

Budbill, David, *Moment to Moment: Poems of a Mountain Recluse.* Port Townsend, Washington: Copper Canton Press, 1975

Busch, Akiko, *Geography of Home: Writings on Where We Live.* New York: Princeton Architectural Press, 1999

Casey, Edward S. *Earth-Mapping: Artists Reshaping* Landscape.:..Minneapolis: University of Minnesota Press, 2005.

Casey, Edward S. *Representing Place: Landscape Painting and Maps..* Minneapolis: University of Minnesota Press 2002

Cloke, Paul and Jo Little, Eds. *Contested Countryside Cultures* London and New York: Routledge, 1997

Cresswell, Tim, *Place: A Short Introduction* .Malden, MA: Blackwell Publishing, 2004

Da Vinci, Leonardo. *Leonardo on Art and The Artist.* Mineola, New York: Dover

Publications, Inc, 2002

Daley, Yvonne, *Vermont Writers: A State of Mind.* Hanover and London: University

Press of New England, 2005

Elgin, Duane, *Voluntary Simplicity.* New York: Quill, William Morrow, 1981

Gallagher, Winifred. *The Power of Place: How Our Surroundings Shape Our Thoughts, Emotions and Actions.* New York: Harper Perennial, 1993

Goldberg, Natalie, *Writing Down the Bones: Freeing the Writer Within.* Boston and London: Shambhala, 2005

Goldsworthy, Andy, *A Collaboration With Nature.* New York: Abrams,1987

Hall, Donald *The Best Day, The Worst Day.* New York: Houghton Miff!in Company, 2005

Hall, Donald. *The Painted Bed.* New York: Houghton Mifflin Company, 2002

Harrison, Sabrina Ward, *Spilling Open: The Art of Becoming Yourself New York:* Villard. 2008

Hinchman, Hannah, *A Trail Through Leaves: The Journal As A path To Place ;* New York: W.W. Norton & Company, 1997

hooks, bell, *Belonging: A Culture of Place.* New York and London: Routledge, 2008

hooks, bell, *Art on My Mind: Visual Politics.* New York: New Press, 1995

Hubbard, RH, *Canadian Landscape Painting, 1670-1930: The Artist and the Land.* Madison: University of Wisconsin Press, 1973

Husher, Helen .*A View from Vermont: Everyday Life in America.* Guilford, Connecticut: The Globe Pequot Press, 2004

Jensen, Derrick, *Listening to the Land: Conversations About Nature, Culture, and Eros.* San Francisco: Sierra Book Club, 1995.

Kahn, Wolf, *Wolf Kahn's America: An Artist's Travels.* New York: Harry N. Abrams, Inc.,2003

Keizer, Garret, *No Place But Here: A Teacher's Vocation in a Rural Community.*

Hanover and London: University Press of New England, 1988

Kent, Rockwell, *Rockwell Kent: Master of World Painting.* New York: Harry N. Abrams, Inc., 1976

Kernan, Sean, *Among Trees*. New York, New York: Artisan, 2001

Kenyon, Jane, *Collected Poems*. Saint Paul,Minnesota: First Greywolf Printing, 2005

Kwon, Miwon. *One Place After Another: Site-Specific Art and Locational Identity*. Cambridge, Massachusetts: The MIT Press (2004)

Leopold, Aldo. *For the Health of the Land*. Washington D C: Island Press (1999)

Lippard, Lucy R. *The Lure of the Local: Senses of Place in a Multicentered Society*. New York: The New Press, 1997

Mairs, Nancy. *Remembering the Bonehouse: An Erotics of Place and Space*. Boston, Massachusetts: Beacon Press, 1995

Markonish, Denise, Ed, *Badlands: New Horizons in Landscape""* North Adams, Massachusetts: Mass MoCA, 2008.

Meisel, Louis K. *Photorealism since 1980*. New York: Harry N. Abrams, Inc., 1993

Miller, John, Granite & *Cedar*. Hanover, New Hampshire: University Press of New England, 2001

Miller, Robbin, "Offended To Be Called a 'Fiatlander' *Livin': The Vermont Way*. September/October 2007 (38-39)

Ritchie, Donald *A.,Doing Oral History: A Practical Guide*. New York: Oxford University Press, 2003

Rule, Rebecca, *Could Have Been Worse*. Concord, New Hampshin: Plaidswede Publishing, 2006

Ryden, Kent, *Mapping the Invisible Landscape: Folklore, Writing, and the Sense of Place*. Iowa City: University of lwo Press, 1993

Sawin, Martica, *Wolf Kahn: Landscape Painter*. New **Yon:** Taplinger Publishing Company, 1981

Shores, Venila *Lovina,_Lyndon: Gem in the Green*. Lyndonville, Vermont: Town of Lyndon, 1986

Snow, Dan, *In the Company of Stone: The Art of The Stone Waif, Waifs and Words*. New York: Artisan, 2001

Snow, Dan, *Listening to Stone*. New York: Artisan, 2008

Snyder, Gary, Rip *Rap* and *Cold Mountain Poems*. Washington DC: Shoemaker & Hoard, 1965

Snyder, Gary, *Mountains and Rivers Without End*. Berkeley: Counterpoint, 1996

Stewart, Susan.,On *Longing: Narratives of the Miniature, the Gigantic, the Souvenir, the Collection.* Durham and London: Duke University Press, 1993

Takaezu, Toshiko. *The Earth in Bloom.* Albany, New York: MEAM Publishing Company, 2005

Tenneson, Joyce. *Wise Women.* New York: Hachette Book Group USA, 2002

Tuan, Yi-Fu, *Topophilia.* New York: Columbia University Press, 1974

Tuan, Yi-Fu. *Space and Place: The Perspective of Experience.* Minneapolis: University of Minnesota Press, 1977

Waldman, Diane, *Elfsworth Kelfy: Drawings, Collages and Prints.* Greenwich, Connecticut: A Paul Bianchini Book, 1971

Weber, Susan Bartlett, Ed. *The Vermont Experience: In Words and Photographs.*

Montpelier, Vermont: Vermont Life Magazine Publishers, 1967

Wooster, Chuck, Ed. *The Outside Story.* Corinth, Vermont: Northern Woodlands, 2007

Wormser, Baron. *The Road Washes Out In Spring* (2 006) Lebanon, New Hampshire: University Press of New

Wormser, Baron *Scattered Chapters: New and Selected Poems* (2008) Louisville, Kentucky: Sarabande Books